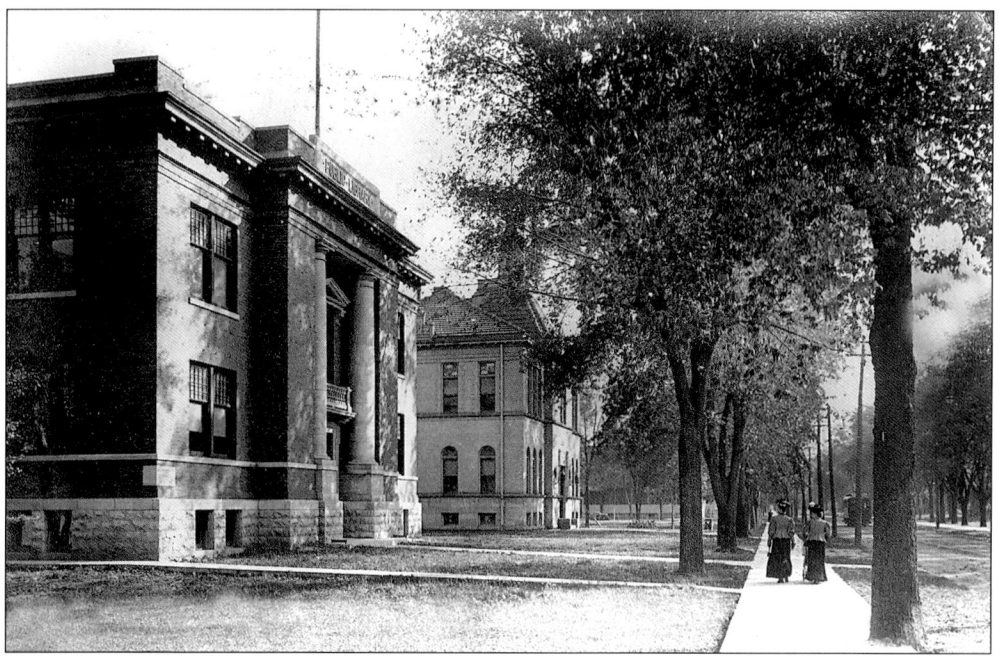

This postcard view of Fifth Avenue, looking south, shows the Maywood Public Library and Village Hall. The 1909 message on the back from Mae to Bennie includes the lines: "Here is our stately library. That streetcar goes right by our house."

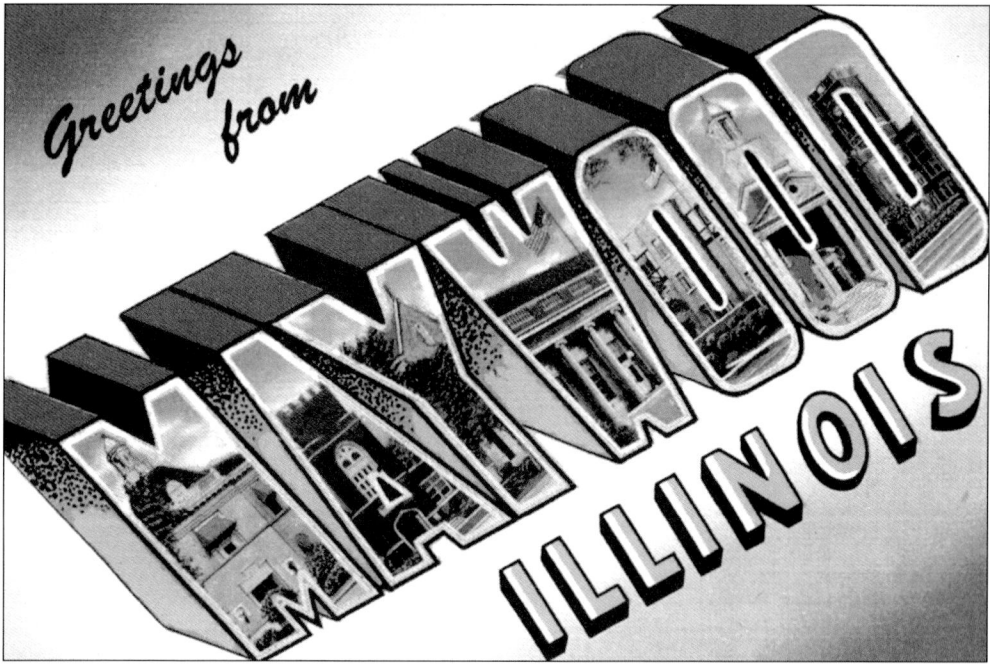

Large-letter postcards were enormously popular during the 1940s. Small scenic views within oversized capital letters spelled the name of a geographic location. Here the "M" in Maywood shows the old Village Hall; the "D" is the tower of Proviso Township High School.

Douglas Deuchler

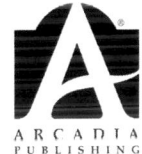

Copyright © 2004 by Douglas Deuchler
ISBN 978-0-7385-3295-0

Published by Arcadia Publishing
Charleston, South Carolina

Printed in the United States of America

Library of Congress Catalog Card Number: 2004105428

For all general information contact Arcadia Publishing at:
Telephone 843-853-2070
Fax 843-853-0044
E-mail sales@arcadiapublishing.com
For customer service and orders:
Toll-Free 1-888-313-2665

Visit us on the Internet at www.arcadiapublishing.com

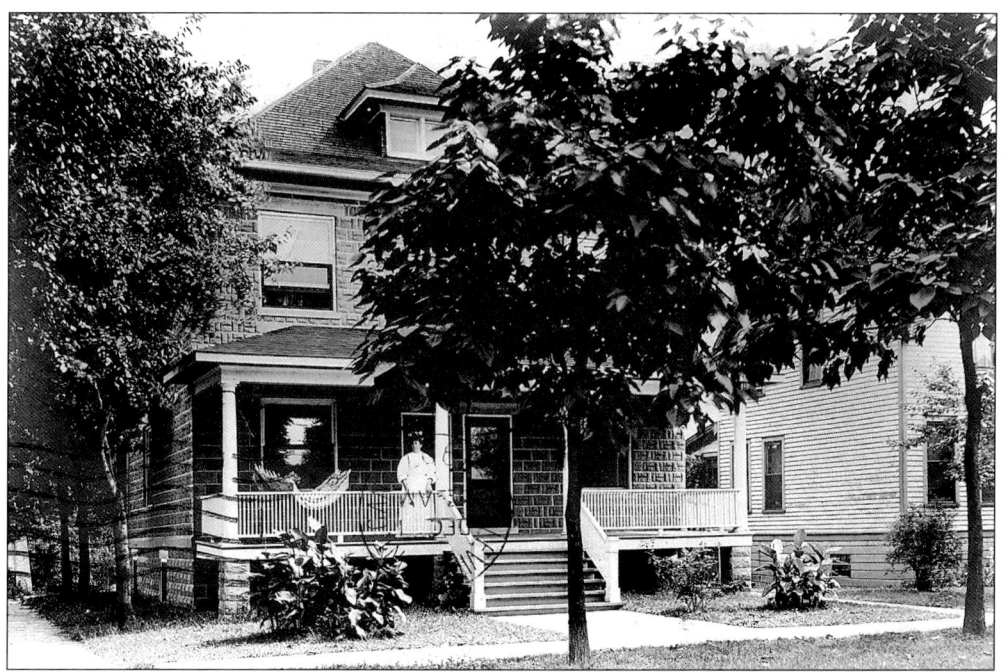

This 1908 postcard shows one of the boxlike "Four Square" homes that could be built with a kit from Sears Roebuck for $1,995. During the heyday of the penny picture postcard, proud new homeowners often had views taken of their sturdy new houses, then mailed them to friends and family, telling them to "Come on out to Maywood!"

Contents

Acknowledgments		6
Introduction		7
1.	In the Beginning	9
2.	The Turn of the 20th Century	29
3.	Suburbia	51
4.	Church Bells and School Bells	81
5.	"Wish You Were Here"	95
6.	Maywood's Hall of Fame	109
7.	Change and Challenge	117

ACKNOWLEDGMENTS

The majority of the images in this volume are from the historical archives of the Maywood Public Library. Executive Director Stan Huntington recognized the significance of this potentially endangered collection of rare materials and took steps to preserve it for future generations. Many thanks to the entire library staff for their assistance and support.

Joe May, a generous and enthusiastic postcard collector, provided scores of vintage views of early Maywood.

Many images by Frank Davis, an amateur photographer of early-20th century Maywood, appear through the generosity of his daughter, Marilyn Leonhart.

Jason Deuchler photographed current Maywood settings.

The author also extends a heartfelt thank you to the many folks who contributed photos, recollections, and advice: Georgann Zussman Amato, Phyllis Baren, Lois Baumann, Tanya Butler, Phyllis Clifton, Carol Clover, Mary Craig, Sheila Ferrari, Kristin Flanders, Ruth Follett, Glenda Hardman Gwynn, the Hurst family, Connie Jensen, Hugh A. Muir, Hazel E. Robinson, Ray Surges, Karen Skinner, Connie Tapia, Rudolph and Glory Wiltjer, and Ruth Yaccino.

Finally, I would like to thank my family for their on-going, loving encouragement: my wife Nancy and my three children—Tim, Jason, and Samantha—who, while growing up, always got dragged to far more "old stuff" and historical markers than they bargained for.

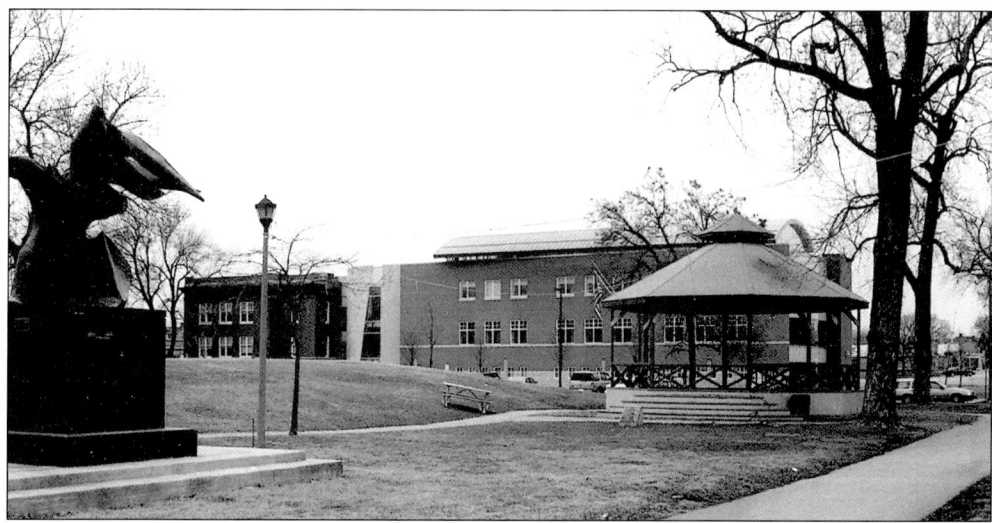

This contemporary view of Maywood Park shows the exciting blend of old and new that characterizes the village. The abstract sculpture by Geraldine McCullough is called "Phoenix Rising." In the distance (left center) can be seen the original 1906 Carnegie Library. The extensive addition (right) opened in 1997, increased the facility from 9,000 to 43,000 square feet. The park gazebo was recreated for the U.S. Bicentennial in 1976, patterned after the original Maywood Band Shell of the early 1900s (page 34).

INTRODUCTION

From the beginning, Maywood was unique among the suburbs of Chicago. Situated along the Des Plaines River, the village was established shortly after the end of the Civil War. Chartered in 1869 on the site of two Indian trails and several large farms, Maywood was founded by Col. William T. Nichols and six other businessmen from Vermont. Nichols presided over the Maywood Land Company, planted 20,000 trees, and laid out his town on a grid like a huge board game with a park in its center.

During the first year of its existence, after 30 new homes were completed in Maywood, the Chicago and North Western Railroad began passenger service. The train became the catalyst of Maywood's early boom period. The new prairie community was so rural in those days that the tracks had to be lined with fences to keep livestock from being hit by the locomotives.

By 1874, a hotel, a post office, a school, a barbershop, and stores like Klug's Meat Market were established, all within walking distance from the tracks. Soon several churches summoned the faithful on Sundays. A small lending library operated out of a rented room in the grand Maywood Hotel, situated near the railway depot.

Maywood grew into a thriving, bustling suburb by the turn of the 20th century. Villagers enjoyed "everything up to date," from chain stores to vaudeville shows, from a state-of-the-art "water works" to 10 miles of paved brick streets. Maywood Hotel was converted into the modern Phoenix Hospital, complete with a nursing school and "mental sanitarium." Swift, affordable public transportation made it easy for those who worked in Chicago's Loop to commute back and forth to their jobs.

Industry made Maywood, too. The American Can Company was the largest local employer, even during the Great Depression. The 1939 "W.P.A. Guide to Illinois" cites Maywood as "a suburban community centering in a factory district along the railroad." The guidebook pointedly notes Maywood's "various distinct neighborhood patterns, all harmonious but racially different."

When Colonel Nichols and company founded Maywood, they undoubtedly never envisioned that their tree-studded rolling pasture would grow so quickly into a town with such urbane diversity. Incomes and ethnic backgrounds differed widely through the years, forming a great range of Maywood lifestyles.

The village became multi-racial very early. Through the years the African-American population shared in the development of the community, although a pattern of residential segregation persisted for many decades.

As Maywood celebrates its 135th anniversary, its population of African American, Latino, and white citizens continue to confront significant challenges. Yet their on-going commitment to positive change is both invigorating and contagious. "Maywood's On The Move," a popular local logo, seems to say it all.

Our pictorial guided tour features over 200 vintage photographs, most of them rarely seen until now. Join me as we salute Maywood, Illinois, and "time travel" back through history to explore the rich heritage of this one-of-a-kind community.

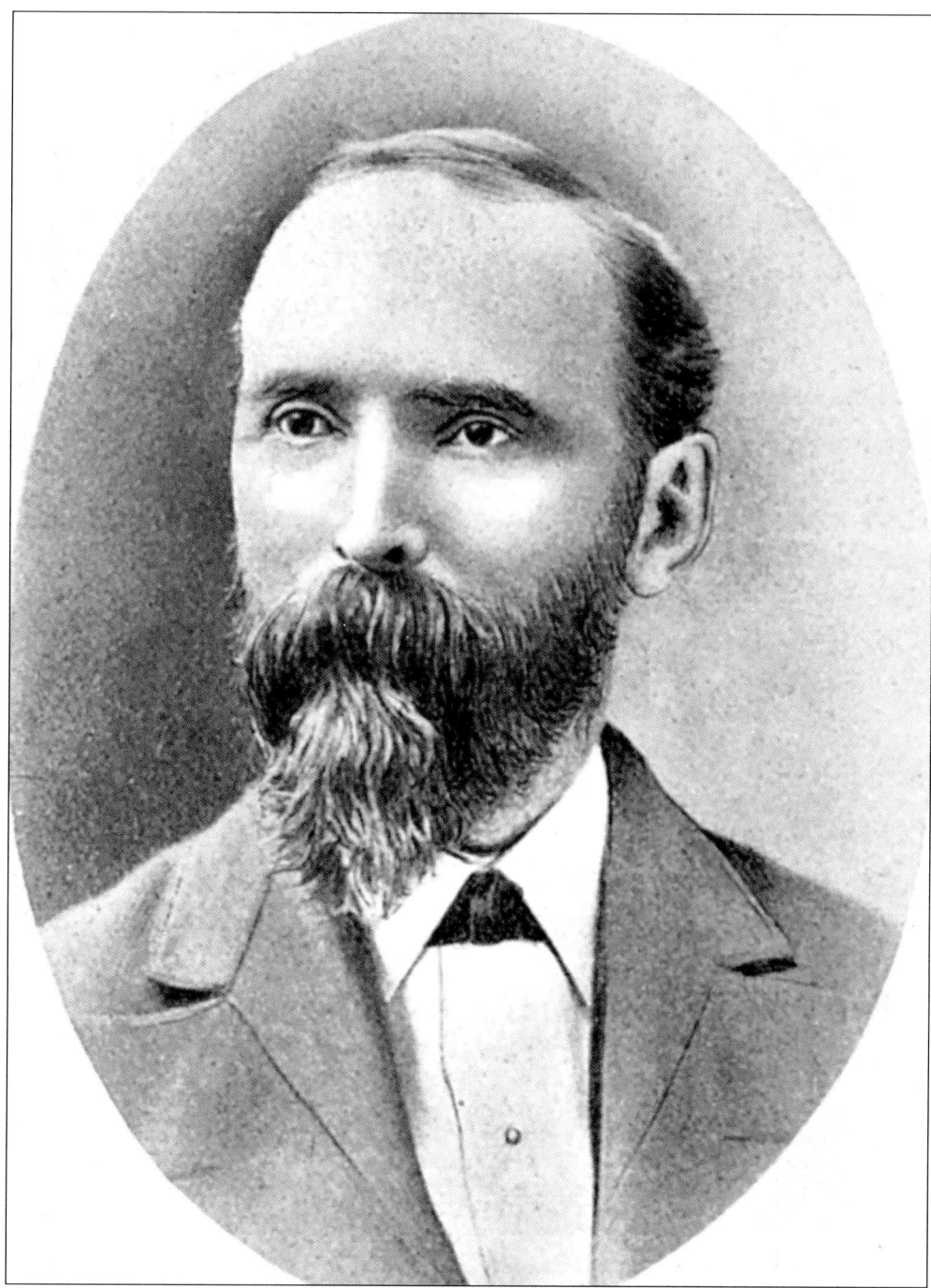

Col. William Tecumseh Nichols (1829–1882), the founder of Maywood, was a veteran of the Battle of Gettysburg. He formed a stock corporation with six other New England businessmen that purchased several large farms on the west bank of the Des Plaines River. For the first 13 years he was president of the Maywood Company and the creative genius behind its development. Colonel Nichols created the name Maywood to honor his recently deceased daughter May and to celebrate the 20,000 trees he had just planted in the new village.

One

IN THE BEGINNING

The Des Plaines River played an important early role. The Potawatomi traveled up and downstream via canoe, hunted in the adjacent forests, and cultivated the flat prairie that would become Maywood.

These native people were driven off their tribal lands in the 1830s, and then banished to Indian reservations beyond the Mississippi River. This removal policy opened up the land to incoming European homesteaders. What's now Maywood was first developed as several large farms.

In 1869, Col. William Nichols of Vermont, a former abolitionist, formed a stock corporation called the Maywood Company that bought up the farmland for $100 an acre. Nichols laid out the village with only four houses planned per block—one on each corner.

A growth spurt occurred after the disastrous Chicago Fire of 1871 when many prosperous Chicagoans moved out to the pleasant, wide-open spaces of the new suburb. Nearly a hundred homes were built the following year.

By 1875 there were 16 trains stopping daily in Maywood. After the Norton Brothers opened their can factory in the early 1880s, the village entered a boom period. The population doubled between 1880 and 1890.

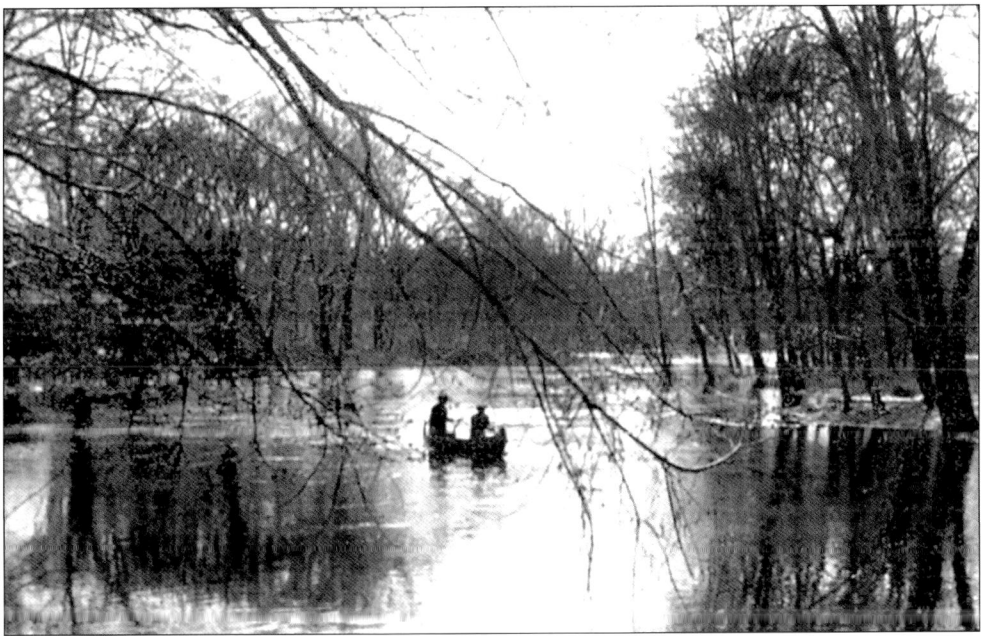

Whether or not the French explorers Pere Marquette and Louis Joliet ever walked on ground that's now Maywood is unknown. But it's certain they used the Des Plaines River as a short cut to the Great Lakes in 1673. Two hundred and fifty years later, in 1923, two young men travel downstream via canoe near the Lake Street Bridge.

The Des Plaines River played a key role in Potawatomi life. The Indians used it as their "expressway." They hunted in what's now the Forest Preserve and cultivated squash, maize (corn), and melons on the flat prairie that became Maywood. The Indians exchanged beaver, mink, and muskrat pelts with French fur traders for silver bracelets, buckles, and ornamental hair clips.

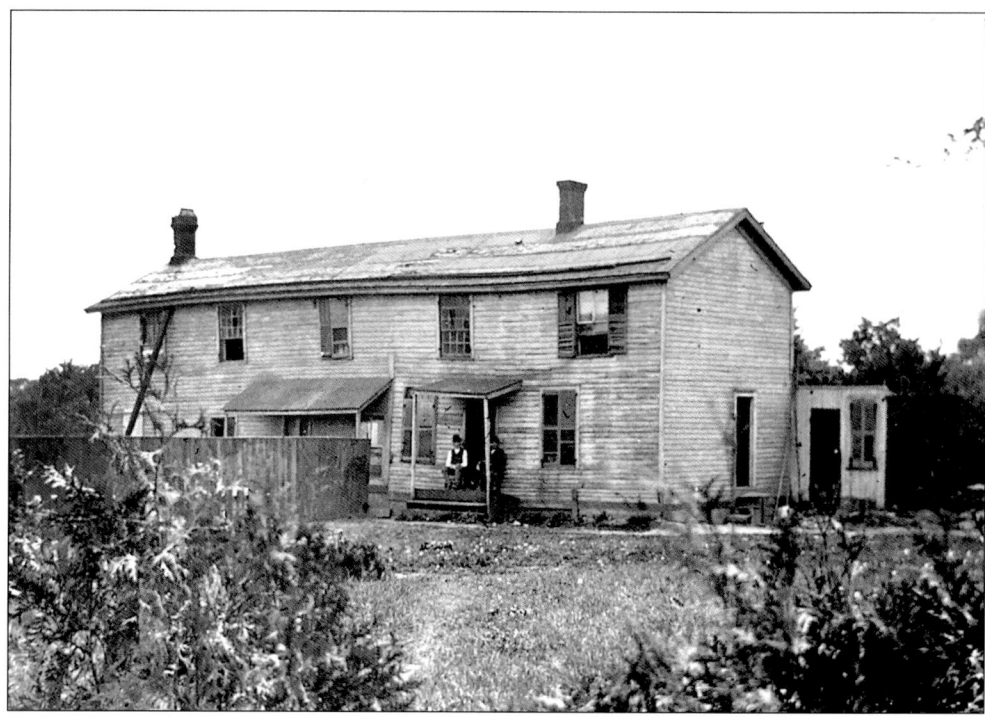

Before the Civil War, the "10 Mile House" on Lake Street at the edge of the Des Plaines River was a stagecoach rest stop that secretly and dangerously functioned as an Underground Railroad "stop"—a hiding place for runaway slaves. Even in northern Illinois, slave catchers scoured the region, motivated by rewards for returning runaways to their owners. The inn was 10 miles, or a day's ride, from Chicago.

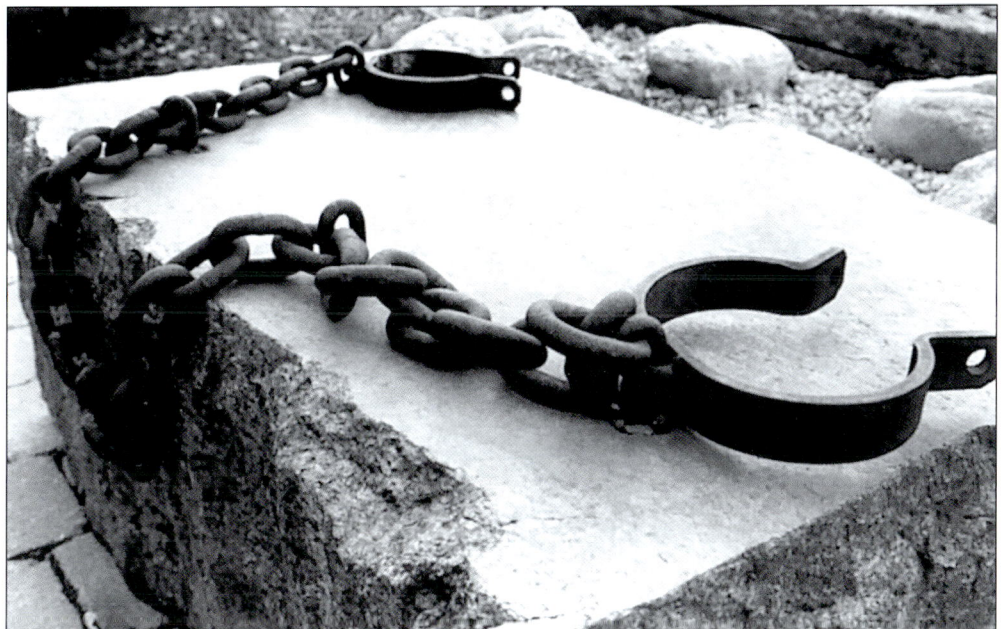

These slave manacles are part of a memorial erected in 2001 on the site of the "10 Miles House," now a McDonald's restaurant, Lake Street at First Avenue. The Underground Railroad was not an actual railroad but an organization that provided escaped slaves with a safe hiding place in their flight to safety. Fugitives, who were moved under cover of night, hid in secret rooms during daylight. Those with small children or babies who might cry out or draw attention to the others were hidden in the brush along the riverbank.

This 1858 farmhouse, Maywood's oldest building, still stands at 104 Oak Street, facing Veterans Park. Farm auctions were once held from the balcony. Since 1974 the structure has been the Way Back Inn, a transitional living facility for men recovering from chemical dependency.

Close-knit family units living together under one roof in the 19th century often included elderly parents as well as adult unmarried siblings.

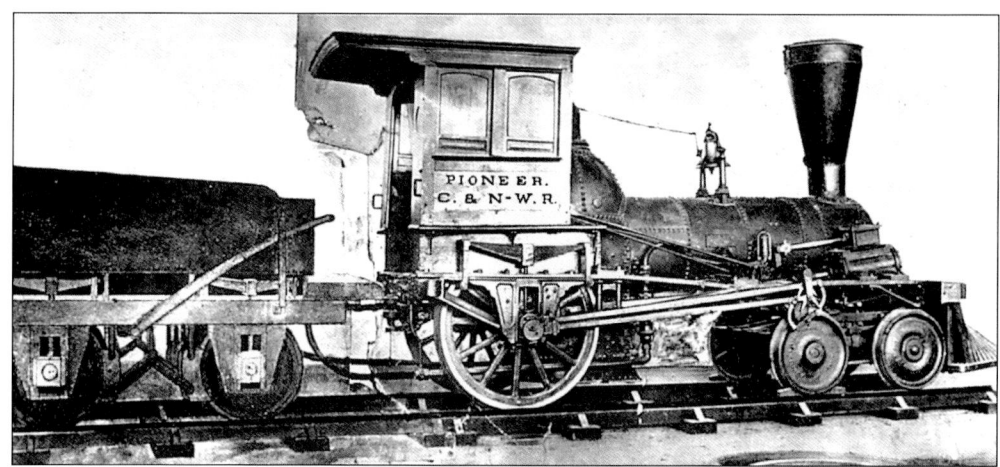
In 1849, the Chicago & Galena Union Railroad laid track along the Lake Street stagecoach route that ran west from Chicago. The railroad would become the key to the economic growth of the early village of Maywood.

Maywood's first general store doubled as a post office. The railroad was such a prime influence in the development of the village that most commercial establishments clustered within a block or two from the tracks. Everything from pickles to crackers was weighed and sold from a barrel.

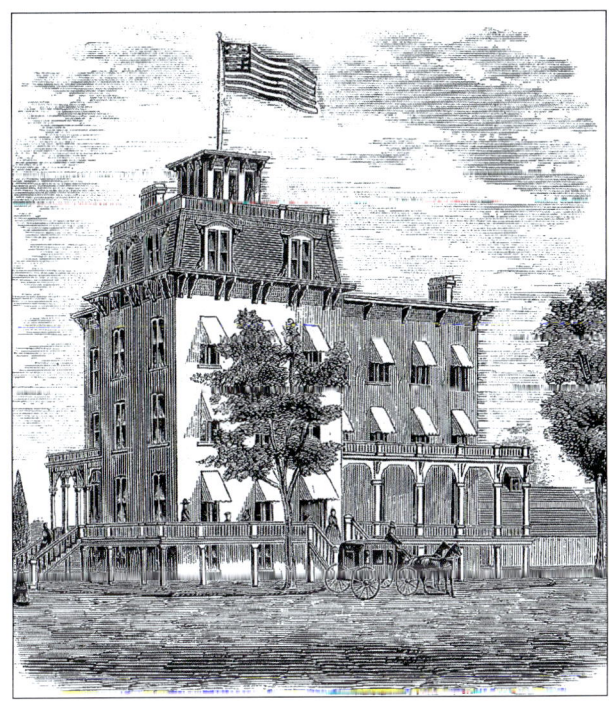

In 1870, the four-story Maywood Hotel, the showiest of the early buildings, was erected across from the railroad depot on the southeast corner of Fifth Avenue and St. Charles Road at the then-astronomical cost of $30,000. The structure had a mansard roof with an observation tower. Hotel guests, who included some of the most fashionable people of the era, enjoyed sitting on the veranda watching the trains go by.

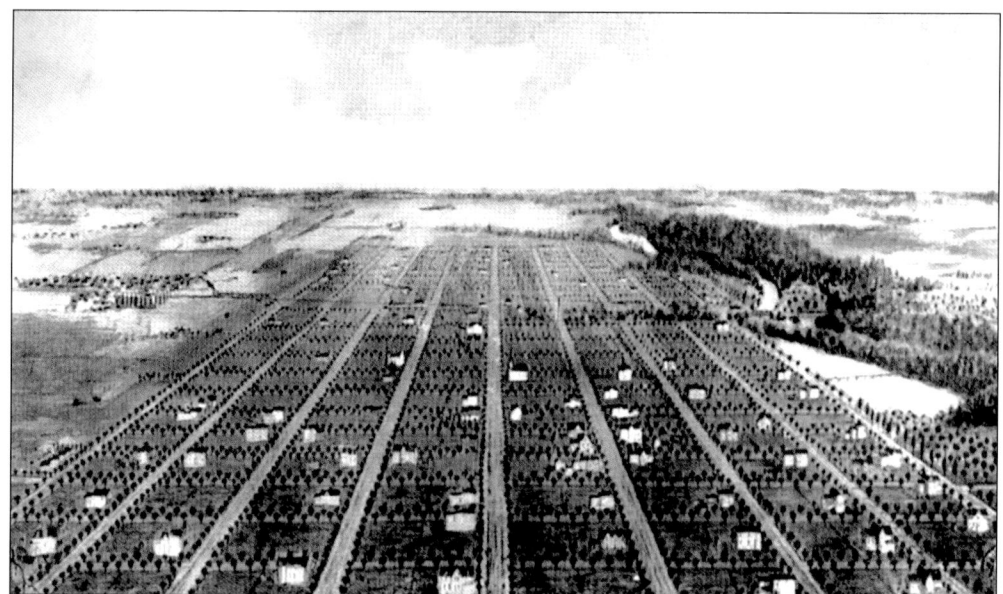

Colonel Nichols and his associate land speculators laid out their new "railroad suburb" on a standardized grid plan. This bird's eye view from 1874 shows an eastbound locomotive (top left) and the placid Des Plaines River (right). Mail sacks were thrown to the ground from the speeding trains.

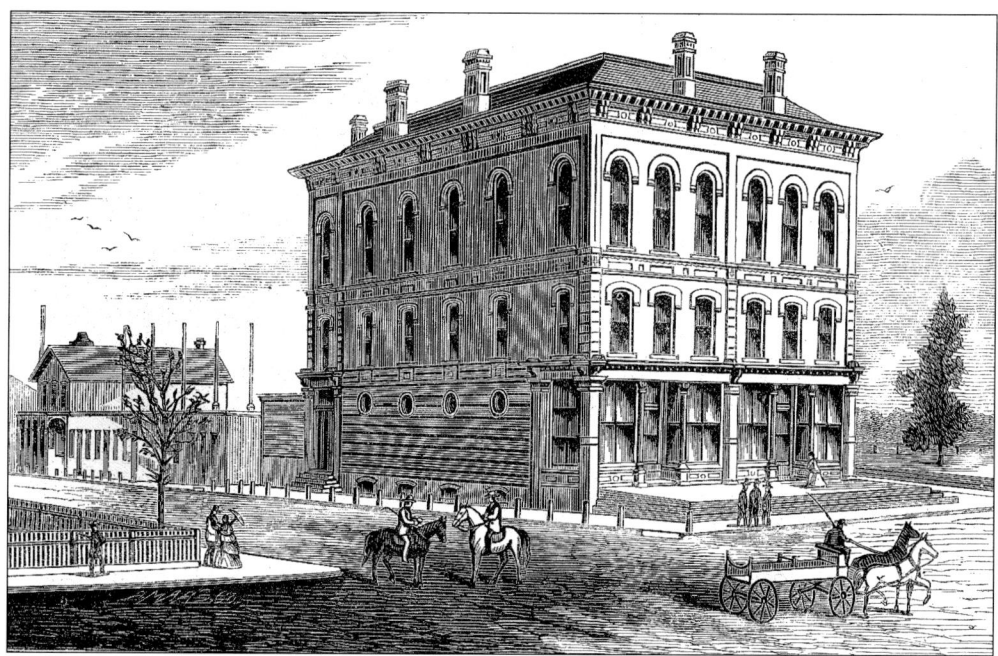

Maywood Hall, facing Fifth Avenue at St. Charles Road, was the social hub of the new village. The post office was on the first floor. The offices of the Maywood Company were on the second floor. The spacious third floor was used as a hall for political caucuses and dances. There was a stage where routing troupes presented minstrel shows and melodramas like Uncle Tom's Cabin

In addition to planting 20,000 trees, Colonel Nichols created a 16-acre park that included a lagoon, an ice cream stand, benches for 2,000 people, a music band shell, an open-air dance floor, and this 124-foot high observatory.

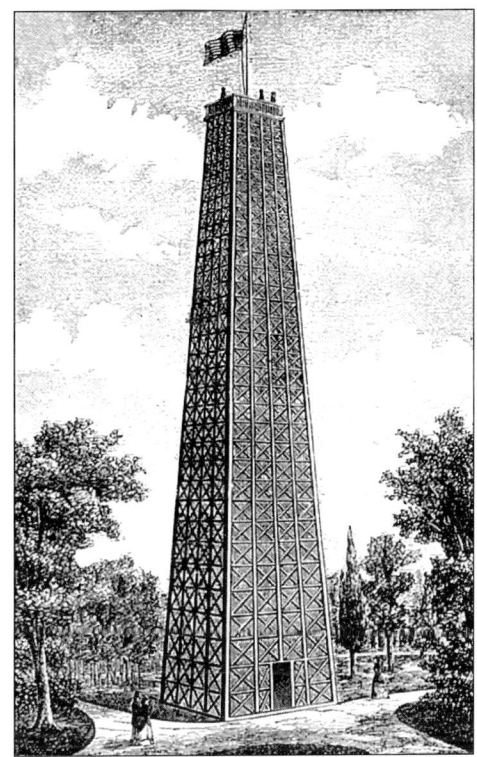

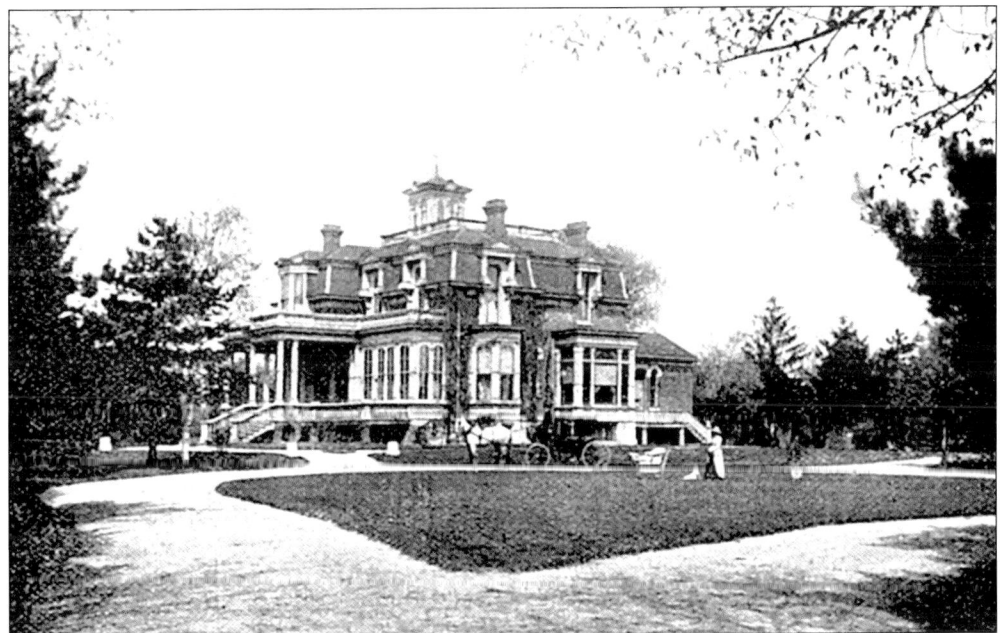

One of the grand homes built during the boom period after the Great Chicago Fire of 1871 was the French-style "Second Empire" house belonging to Civil War hero, Gen. William Sooy Smith, at Eighth Avenue and St. Charles Road. It featured a sloping mansard roof that provided an extra floor in the attic level. The structure was razed in the early 20th century as American Can expanded its plant.

Many prosperous and fashionable families lived in the elegant homes of early Maywood in the 1870s and 1880s.

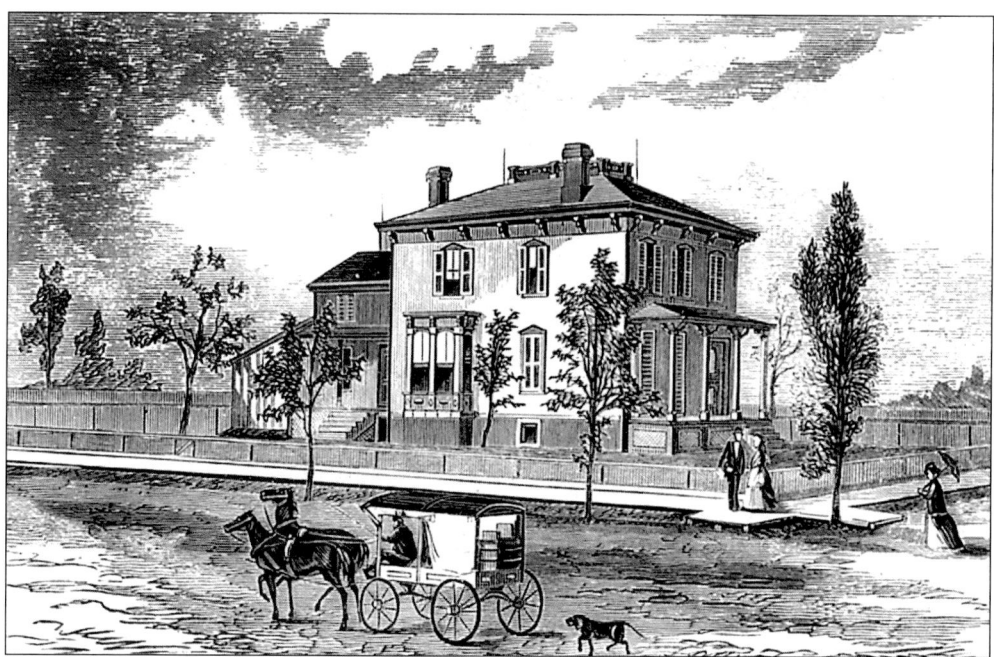

Sidewalks were raised planks laid side by side. Opossums, raccoons, rabbits, and skunks made their homes beneath the boards. Folks who went out at night had to carry lanterns. In rainy weather, the rutted, dirt streets were often impassable for both pedestrians and wagons.

Robert Priestley, 612 South Thirteenth Avenue, was 16 years old when this studio photograph was made in 1888. His father, William Priestley, was a plasterer. One of his contracted projects was the First Methodist Church (page 85). Many of the early African-American residents of Maywood were tradesmen and laborers.

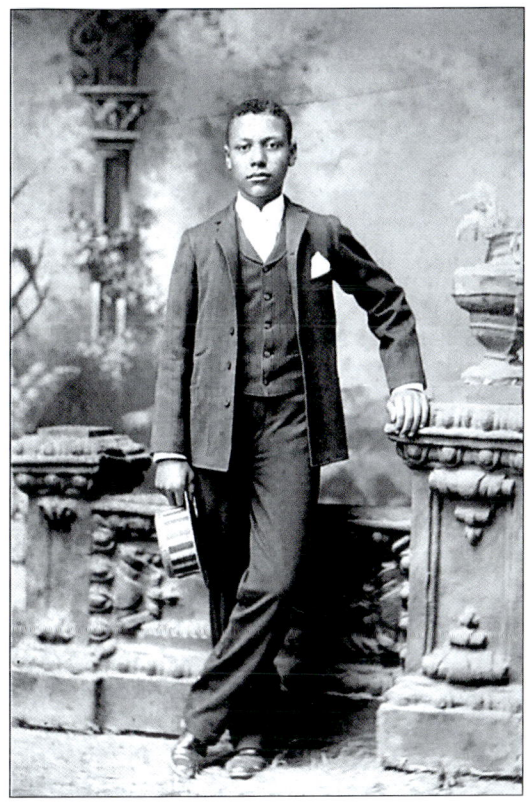

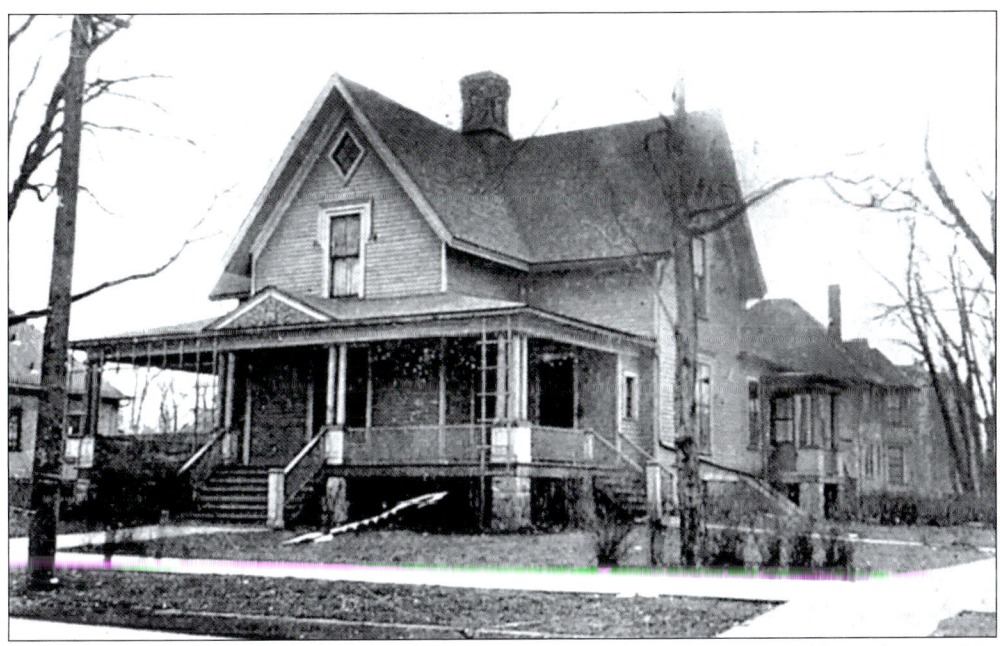

This 1910 postcard shows the third home erected in Maywood, c. 1870, still standing at 304 South Fifth Avenue.

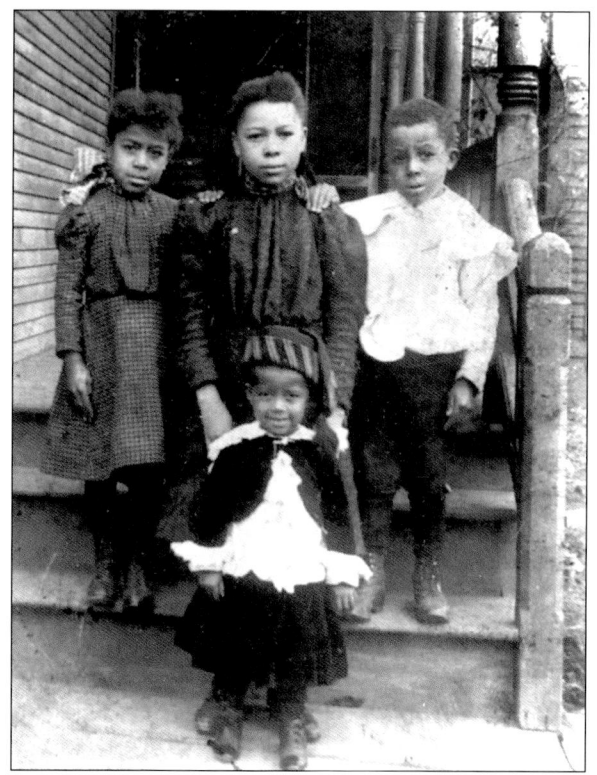

Iva Hurst was a cook at the Palmer House in Chicago's Loop in the 1880s when he saw a real estate handbill advertising a land sale in Maywood. Hurst and his wife Amanda purchased two lots, and then built a three-room home at 417 South Thirteenth Avenue. These four of their children are Margaret, Irene, Ervin, and Baby Sidney. The Hurst family has lived in Maywood for over 120 years. The house is sill standing.

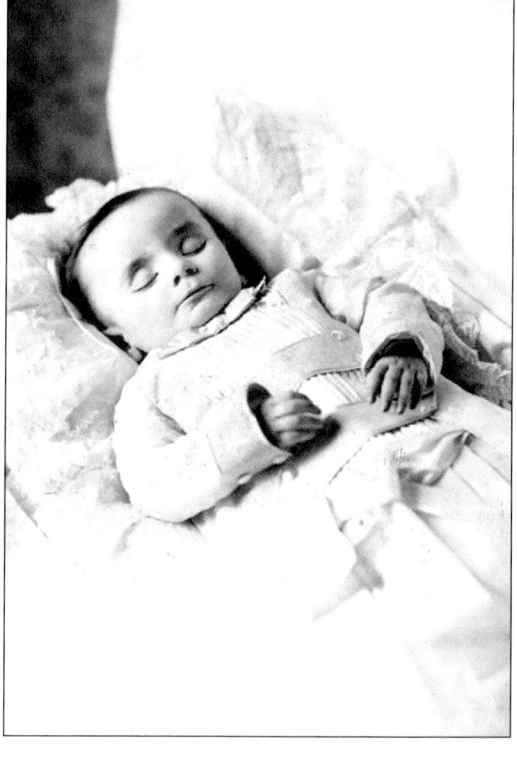

When an infant died in the late 19th century, the postmortem photograph was often the only likeness of the "departed angel" the bereaved parents would ever have. Postmortem photos were mailed to relatives who lived too far away to attend the funeral. This male infant died of diphtheria in 1884

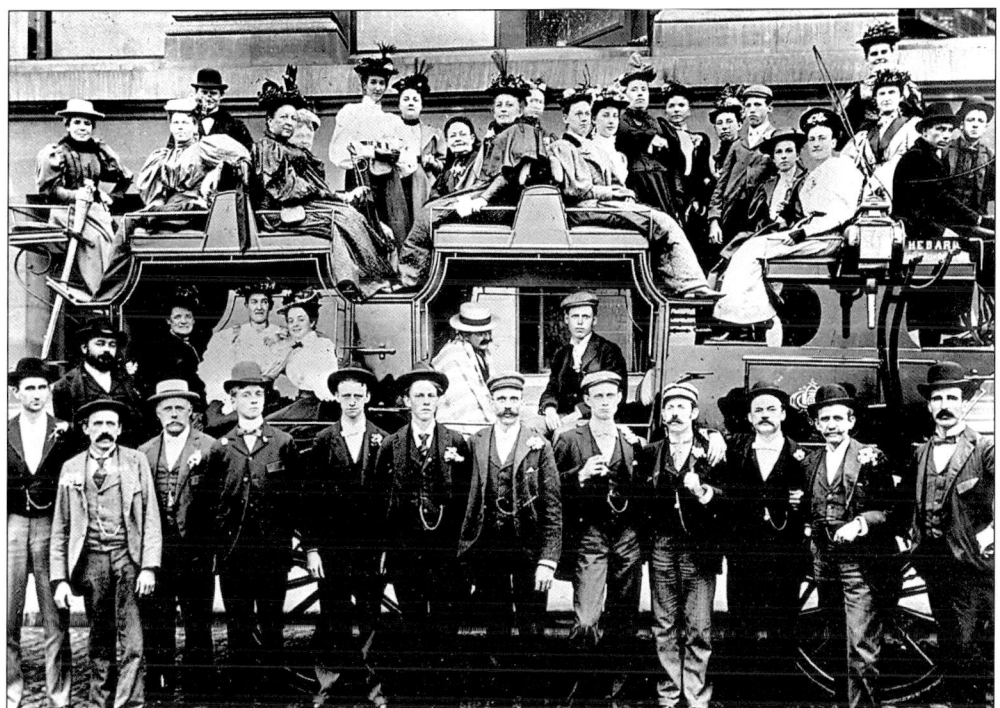

A "Tally Ho" was an oversized, horse-drawn coach that could be booked for outings. These three dozen fun-seekers from the First Congregational Church were heading out for an "excursion" on Decoration (Memorial) Day—the official start of the picnic season—in 1896. No one in Victorian times ever left home without a hat.

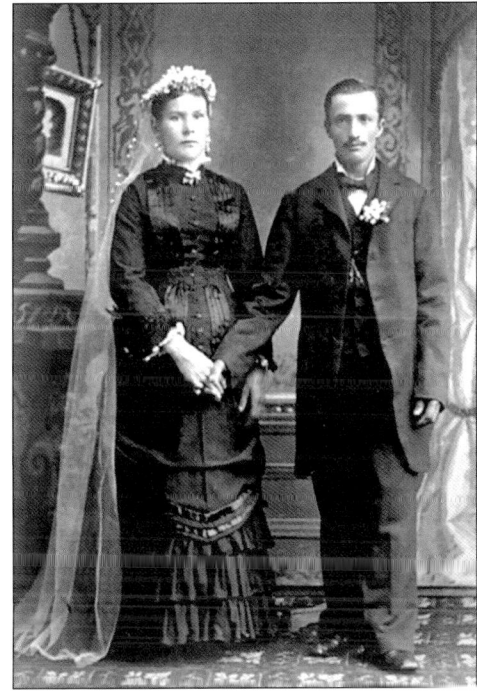

A white wedding gown that was only worn once was considered an impractical garment. Brides simply wore their best dress or a traditional ethnic wedding costume. An expensive, one-time use white dress came into fashion around 1900 as a way of showing off a family's status.

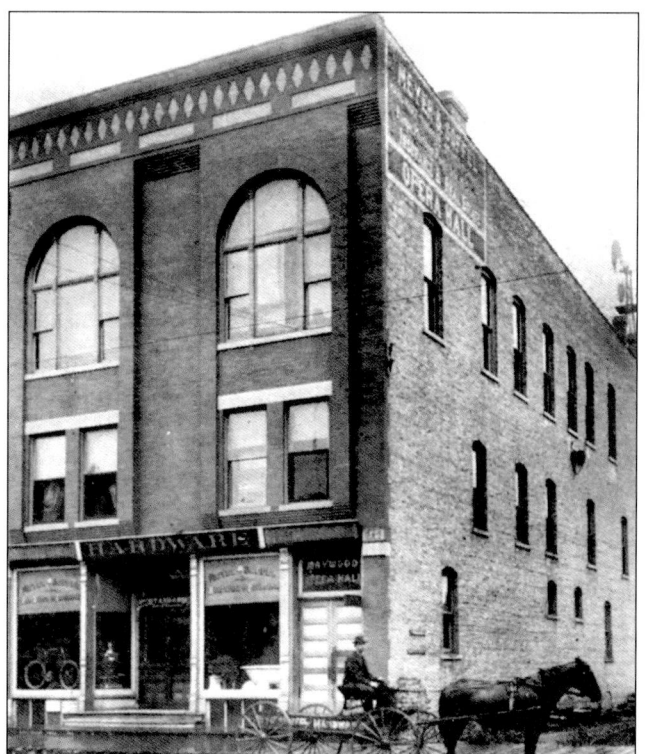

The Maywood Opera House, 220 North Fifth Avenue, is seen here in the 1890s. The Meyer & Soffell Store, on the first floor, sold everything from corsets to horse collars. The Bronco Thrift Shop has been located there since the 1970s. "Stairway of the Stars," a dance school founded by Lois Baumann, has occupied the third floor for over 30 years.

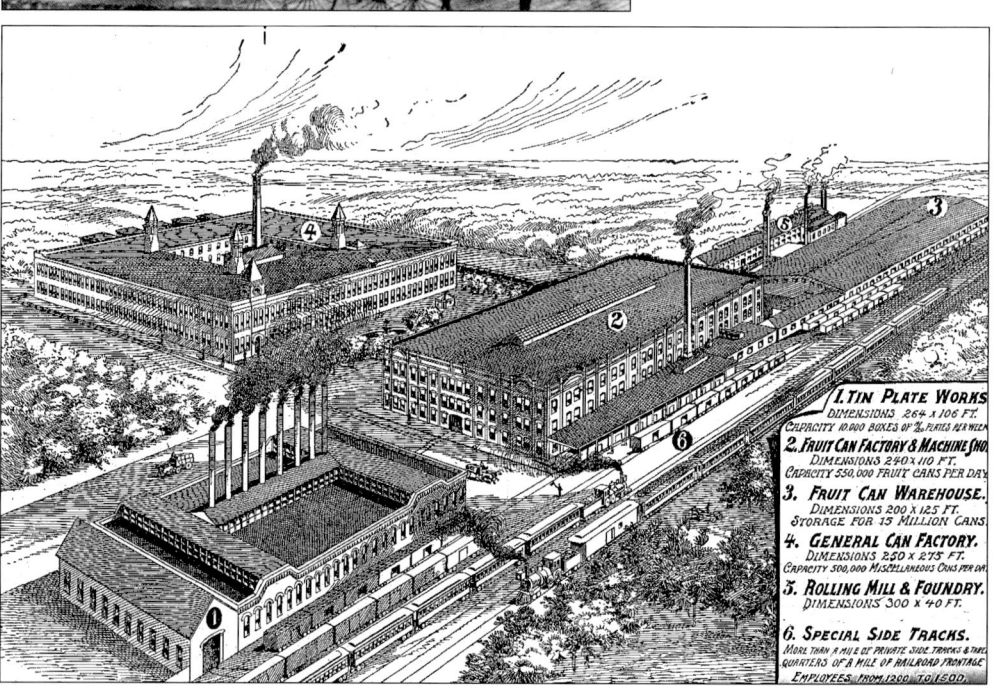

The post-Civil War industrial boom had a strong influence on early Maywood. The Norton Brothers' tin can making plant was quickly recognized for its industrial efficiency. Machinery made cans from sheets of steel, then automatically counted them as they were loaded into a freight car. By the 1890s, Maywood was one of the chief can manufacturing centers of the world.

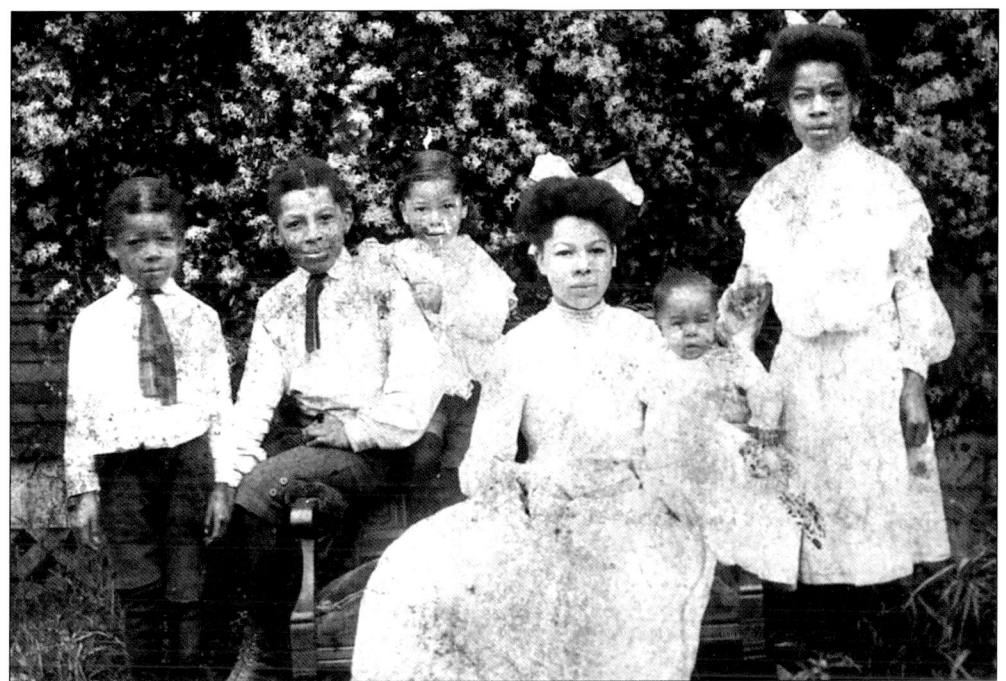

Maywood's Jews and African Americans lived in the same neighborhood. Here are the six children of Iva and Amanda Hurst, c. 1905. They were all delivered by a Jewish midwife named Mrs. Bella Barsky.

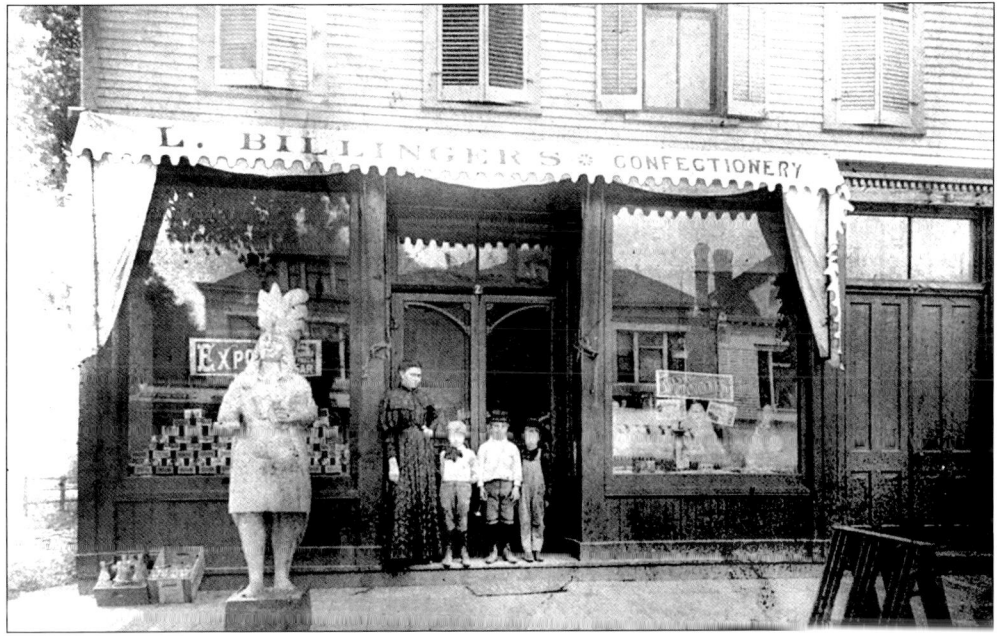

Leander Billinger's Confectionery, which was conveniently situated by the train depot on the northwest corner of Fifth Avenue and Main Street, sold candy, cigars, and newspapers in the 1890s. Mrs. Catherine Billinger and her three boys are standing near the obligatory cigar-store Indian.

21

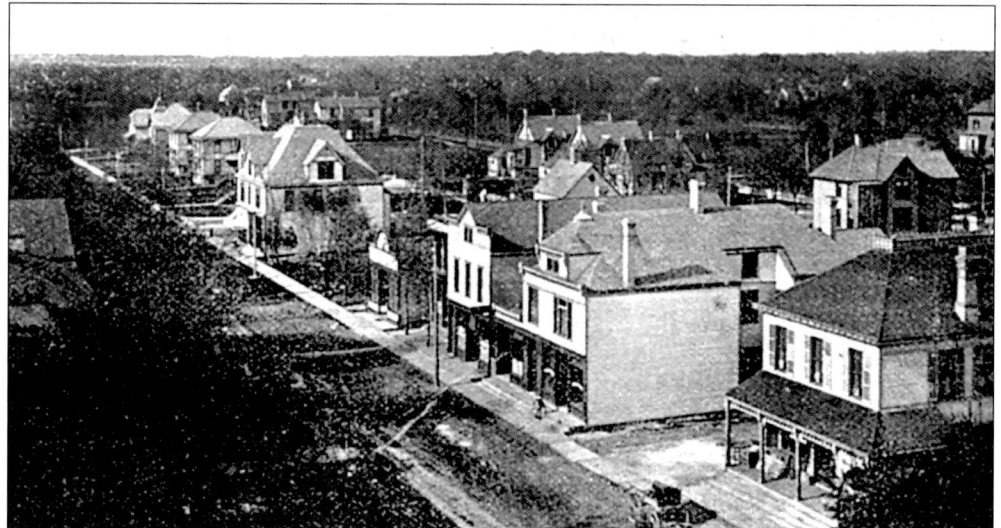

This photo from the late 1880s shows Klug's Meat Market at the northeast corner of Fifth Avenue and Main Street. The Klug brothers—Julius, Oscar, and Herman—were often joined behind the counter by their wives—Paulina, Frances, and Mary.

Looking north on Fifth Avenue, Klug's Meat Market can be seen in the lower right. The muddy streets and horse manure required pedestrians to watch their step! This photo was taken from the roof of Maywood Hall (page 14).

By the 1880s, Maywood was well established as a prosperous village where "any man willing to work can find a job." Employment was available for women, too. These two sisters worked as office clerks at the can factory.

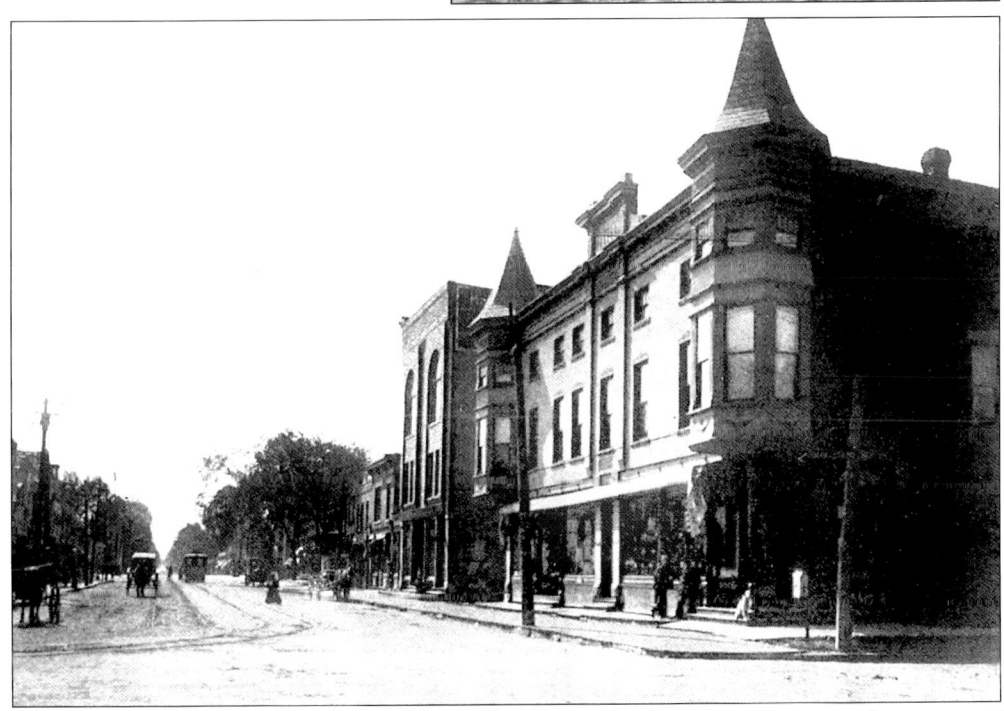

Looking south on Fifth Avenue from Lake Street we see the Opera House in the center of the block, c. 1898. The three-story building (right), with the Queen Anne-style turrets, burned in 1953.

Though jobs were more available and discrimination was less overt in Maywood than in the rural South, African-American villagers were only able to live within one restricted neighborhood. Despite the growing trend of movement north in the late 1880s, nearly 90 percent of the nation's black population still lived in the South.

After an afternoon of cycling and tennis, this gathering of friends posed for a picture on the porch of 300 South Seventh Avenue, c. 1897. There is a vacant lot on this site today.

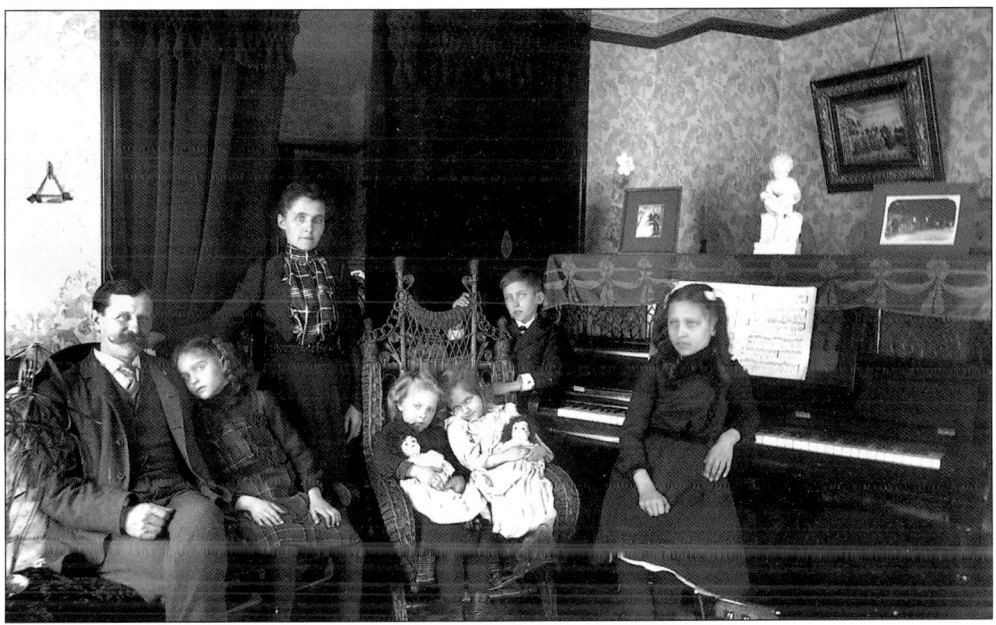

Patriotic holidays like the Fourth of July always created lots of excitement. This is the intersection of Fifth Avenue and St. Charles Road. Note the streetcar tracks and the large mortar and pestle—a symbol that the adjacent storefront (left) belonged to a druggist.

Families of the 1890s aspired to have an upright piano in their formal front parlor. Charles and Elsie Davis pose with their five children at 614 North Eighth Avenue.

25

Most of what's now west central Maywood was once a vast golf course. The ancient Scottish game became widely popular during the 1890s. The Maywood Golf Club at Twentieth Avenue and Washington Boulevard provided full luncheon and dinner menus at the clubhouse.

Cornelius Bryant was the chef at the Maywood Golf Club during the closing years of the 19th century.

People in studio portraits of the Victorian era often appear quite solemn. Photos required very long exposures. Who could smile for a solid minute? This woman, Opal Davis, was a dressmaker.

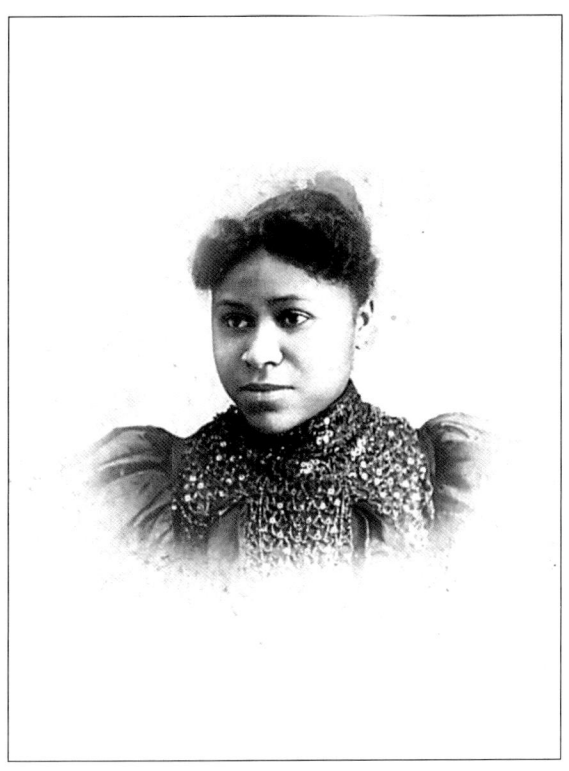

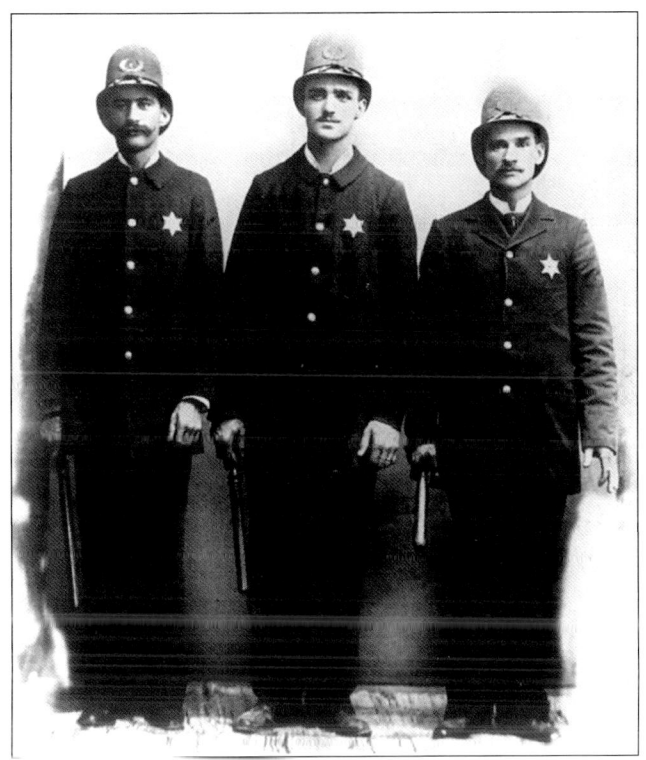

These three police officers, referred to as "constables," comprised the entire Maywood Police Force in 1898. Clad in their new uniforms are, left to right, John Kamphouse, 12 North Fourth Avenue; William Dieke, 305 South Fourth Avenue; Fred Tanton, 320 North Eighth Avenue.

27

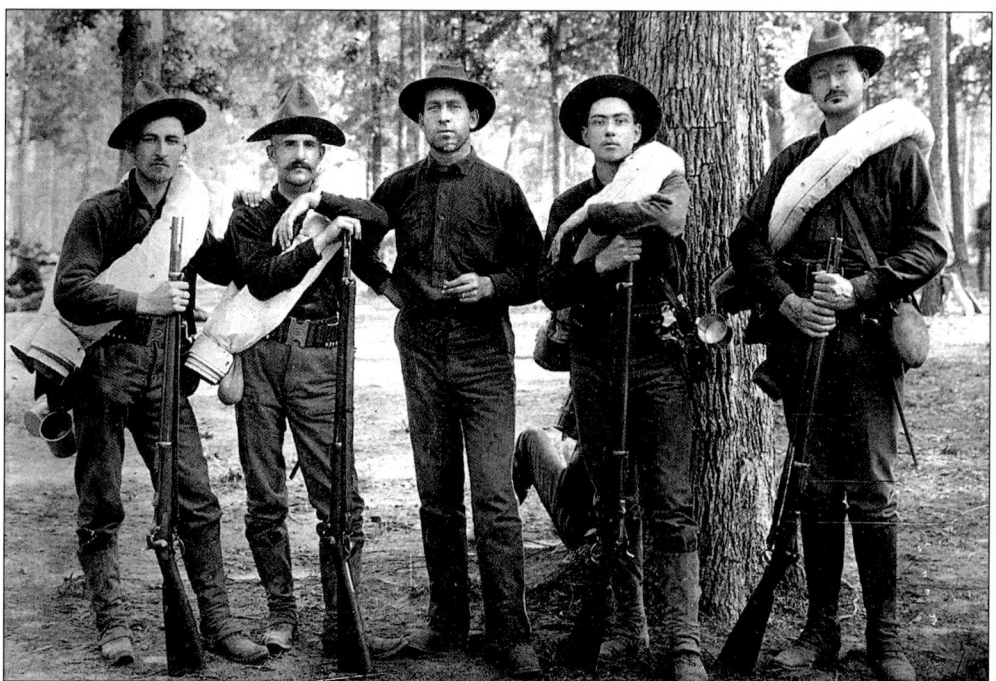

Fred Copeland, William Sinclair, Jack Holland, Harry Evans, and H.A. Owens were five young Maywood men who enlisted to fight in the Spanish American War in 1898. Though there was a relatively quick U.S. victory in Cuba, thousands of soldiers never made it home. They died from malaria and yellow fever.

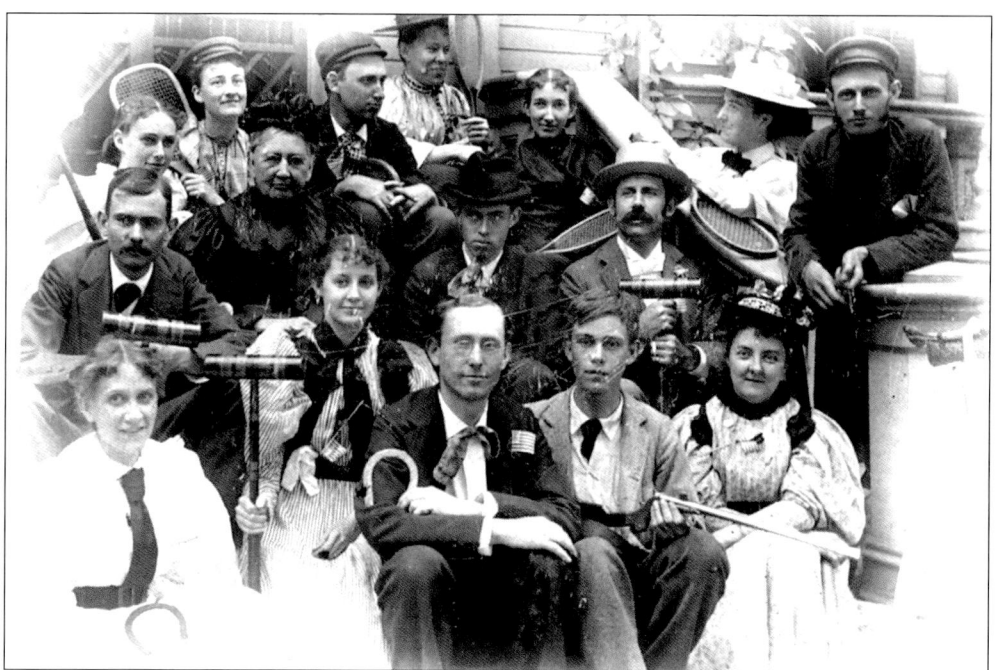

Maywood was a thriving community facing the new 20th century when these villagers went on a tennis and croquet picnic near the banks of the Des Plaines River in the late 1890s.

Two

The Turn of the 20th Century

Maywood's population tripled its size in the first two decades of the 20th century. In 1900 there were 4,532 people living in the village. According to the 1920 census the population had grown to 12,072.

> The 10 Best Reasons Why Maywood Is A Good Residence Town:
> It is high, dry and healthy.
> There is plenty of room to raise flowers, fruits, vegetables and chickens.
> It has a number of paved streets and many more in process of construction.
> It has many cement sidewalks and an ordinance compelling all laid in the future to be cement.
> It has an up-to-date Free Public Library.
> There is free mail delivery twice a day.
> It has churches of all kinds, a reliable bank, a well-equipped hospital, first-class markets and stores.
> It has a five-cent fare from its western limits to State Street in the Loop, thus making the longest ride in Cook County, for the money.
> Maywood can always furnish employment through its expanding industries.
> Maywood has NO SALOONS.
> —from a 1904 promotional brochure

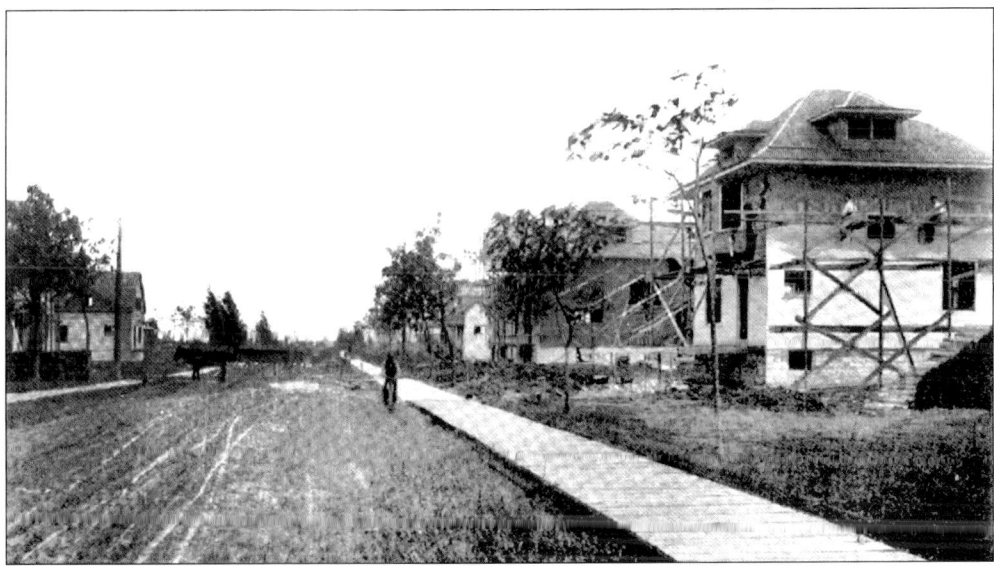

The "Four Square" style of home came to dominate Maywood residential streets in the early 1900s. These were solid, boxlike houses with hipped roofs and centered dormers. This view of Fifteenth Avenue from Randolph Street shows the mud roads and wooden sidewalks of the period.

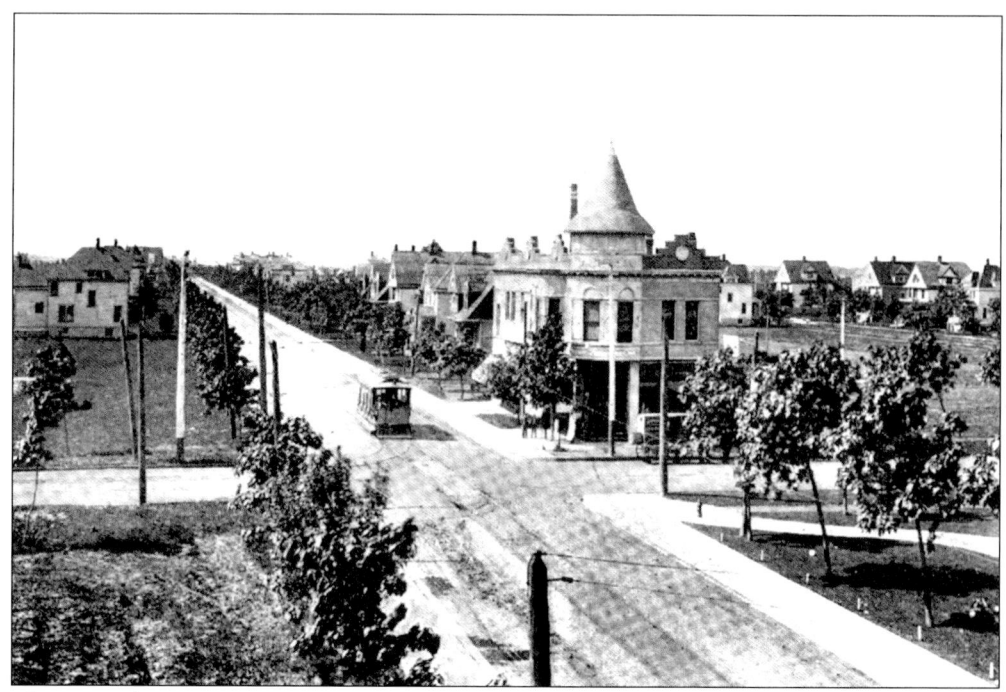

This view shows the intersection of Nineteenth Avenue and St. Charles Road looking south in 1904.

The electric streetcar provided fast, convenient transportation. The nickel fare may seem cheap today but the average wage in 1905 was only 25 cents an hour. This open air "summer streetcar" is heading westbound on Lake Street from Third Avenue.

At the turn of the 20th century, many new villagers were recent immigrants. Christ C. Kjus and his family from Oslo, Norway, seen here in 1901, are riding a bicycle-built-for-six. During the "bicycle fad" before automobiles became affordable, Mr. Kjus ran a bicycle repair shop.

This villager lived on South Thirteenth Avenue. Unlike many suburbs, African Americans could purchase property in Maywood. But they could not live outside the tightly delineated "colored neighborhood"—between Ninth Avenue on the east and Fourteenth Avenue on the west. Restrictive covenant real estate policies made certain that property in adjacent zones could not be sold to people "of African descent."

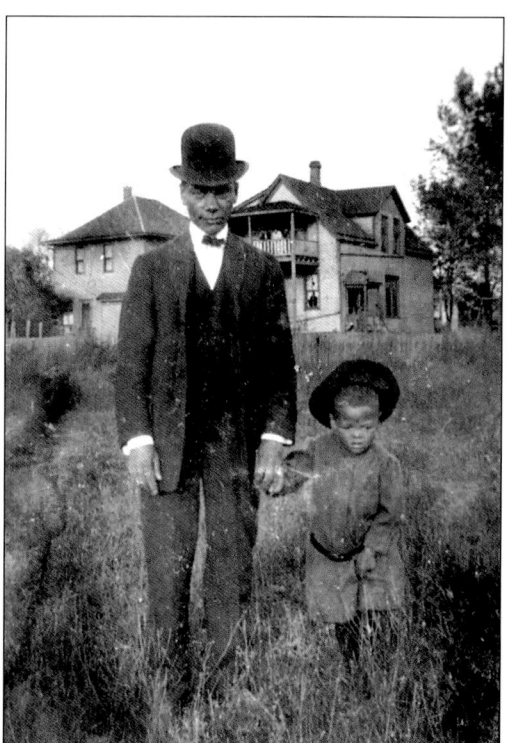

Much of Maywood was a grassy prairie in 1908 when Albert Bush Stump posed with his son, Albert Jr., behind 610 South Thirteenth Avenue. In that era it was possible to tell the race of a villager by his or her address. The code "col" (for "colored") also followed the names of African Americans in Maywood directories.

In 1902, a horse-drawn hose-cart was purchased by the Maywood Fire Department. The horses were rented, as needed, from a local undertaker. Volunteers were paid $3 for each fire attended.

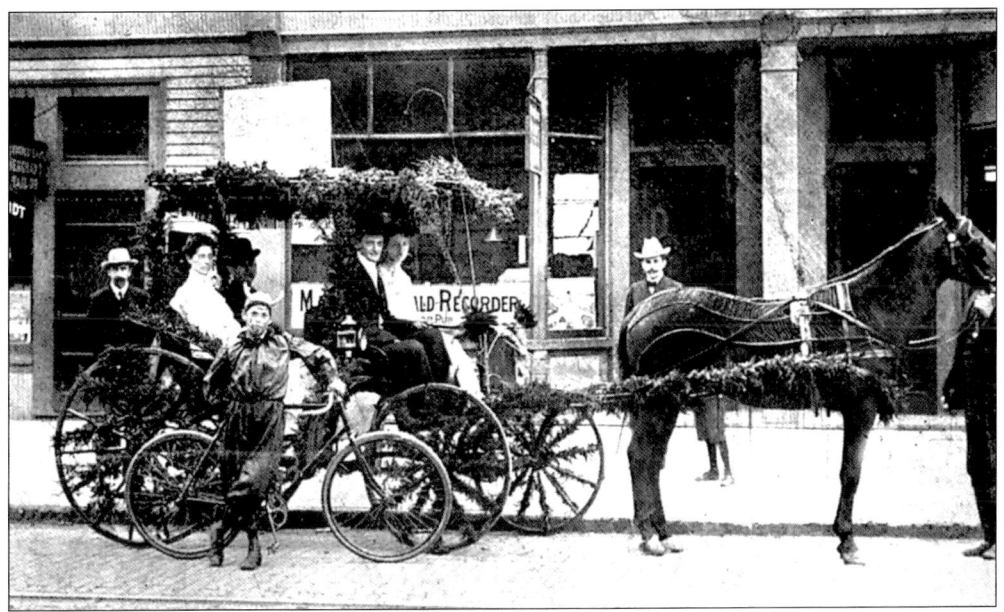

A surrey was a two-seated carriage with a top that often bore fringe. Decorated for the Fourth of July, this vehicle is adorned with fresh greenery. A 1904 group of Maywood Herald-Recorder co-workers pauses along St. Charles Road in front of their newspaper office en route to a picnic in the park. Note the boy dressed as a "printer's devil" and the streetcar tracks on the brick streets.

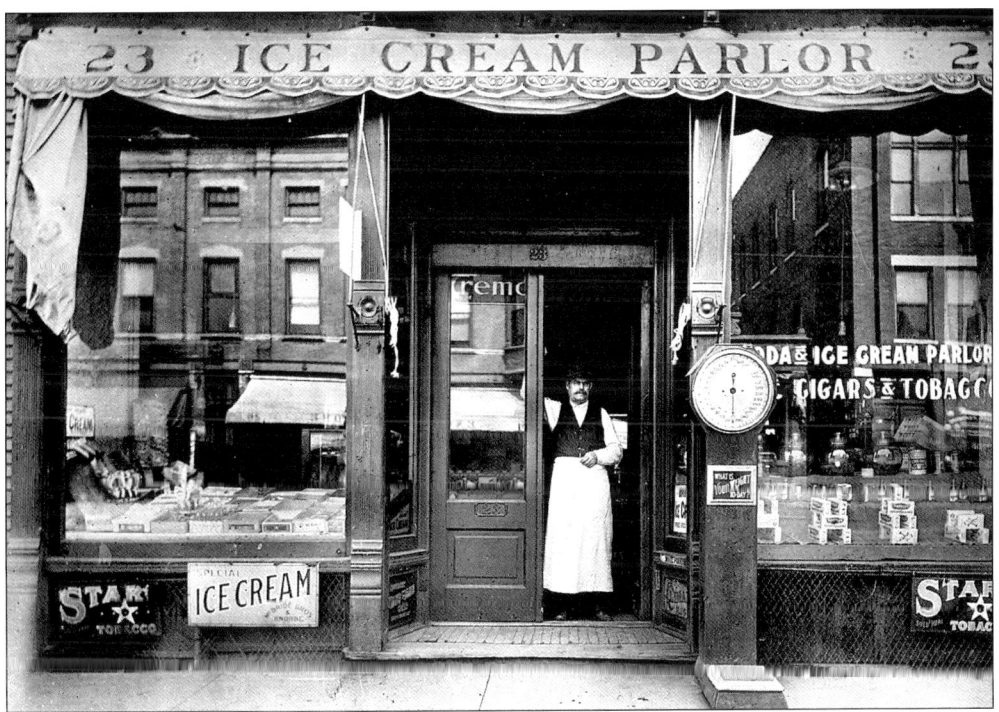

Guiseppe Cortopassi, fresh from Italy, was the proprietor of an ice cream parlor and confectionery at 23 North Fifth Avenue. Note the reflection of the Opera House across the street in the right window.

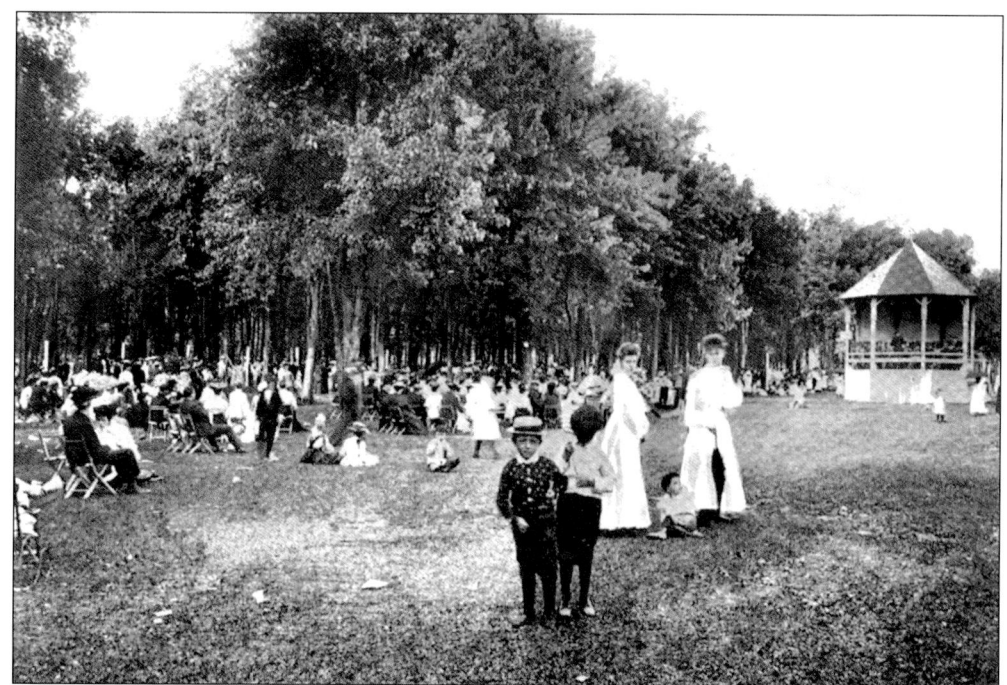
Every Saturday night local bands provided free concerts from the bandstand in Maywood Park. Programs consisted of patriotic music, ragtime, and operetta medleys.

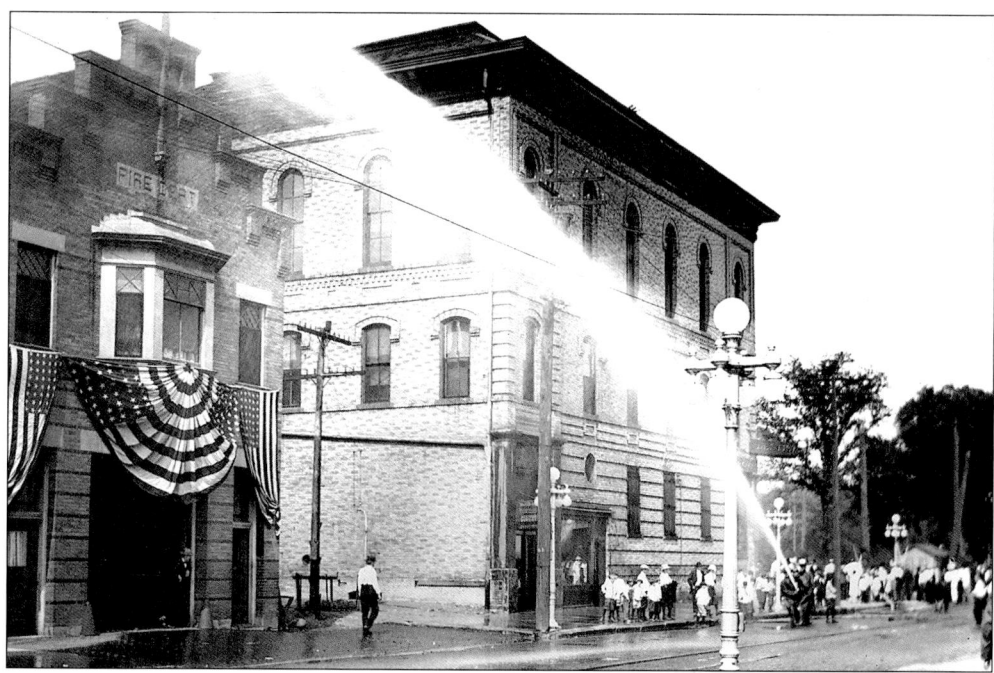
The Fire Department was all bedecked in bunting on July 4, 1913. Maywood Hall (right) at Fifth Avenue and St. Charles Road was razed in 1930 and replaced with a Pure Oil filling station that had a steep roof in the "English Cottage" style. That structure survives as a fast-food drive-in called "Maywood Express."

Maywood was a unique mix of the "new middle class" of salaried professionals who commuted daily to Chicago's Loop and blue collar workers who labored in local factories. Seen here in 1904, Fred and Amelia Banholzer, 514 North Seventh Avenue, were typical of the former group.

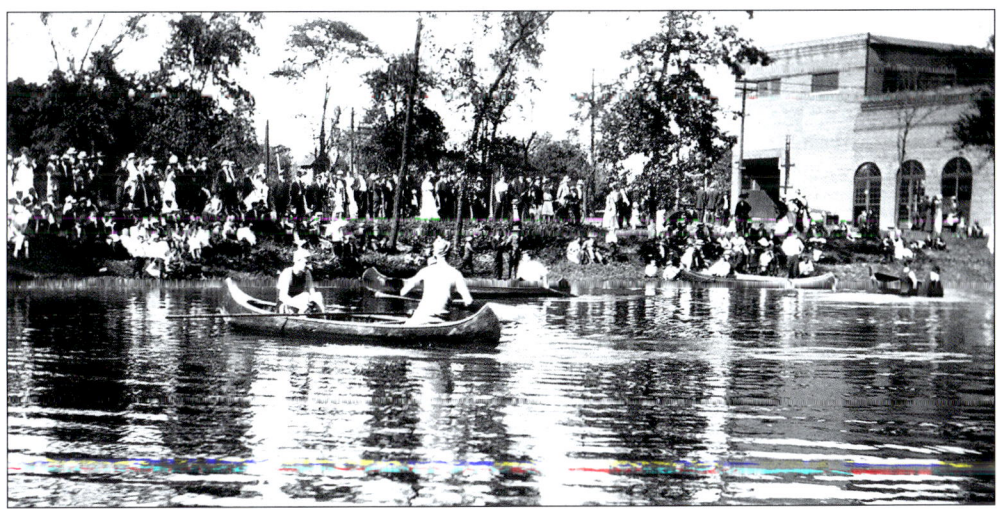

For many decades much of Maywood Park, from First to Fourth Avenues, was a vast lagoon. The canoe races have just begun in this photo taken on July 4, 1915. The pond was drained and completely filled in during a W.P.A. mosquito abatement project in the mid 1930s.

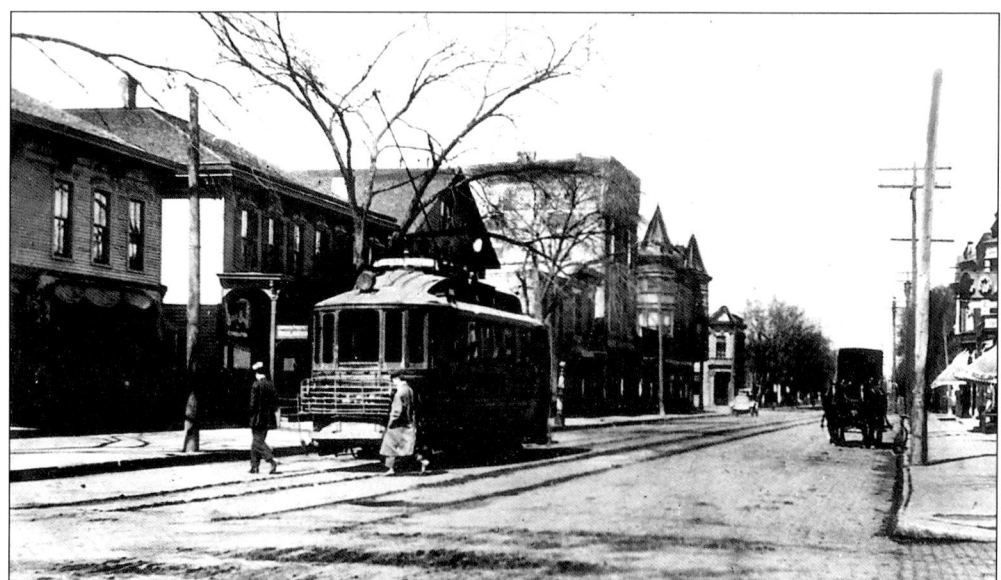

A motorman in the front of the Fifth Avenue streetcar operated the vehicle and clanged the bell, while a conductor in the rear collected fares and called out the stops. After the rush hour the motorman did both jobs. For most villagers, all the necessities of daily life were within walking distance or a quick streetcar ride away. Note the tall Opera House in the center of the photo.

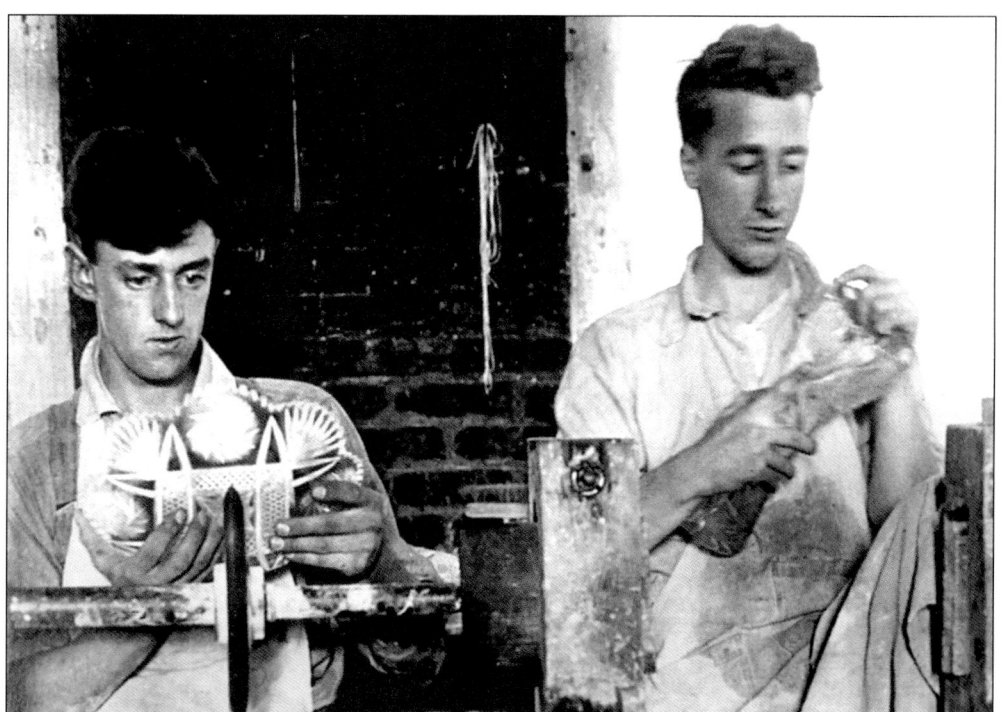

The Paul Richter Cut Glass Works, 619 South Tenth Avenue, just south of Washington Boulevard, was widely known for high quality cut glass work. The factory, which employed about 35 persons, closed in 1940. Here Ed Rudolph, 500 South Tenth Avenue, and Bert Young, 302 South Second Avenue, polish freshly cut glassware.

The fruit bowl shown here is an example of the popular "Maywood" pattern which featured large rosettes about 2 inches in diameter. Richter glassware is highly collectable today.

The iceman came through each neighborhood every other day. People put a large card in the window telling how much ice they needed. On hot days children tagged along behind the ice wagon until the iceman gave them chips of ice to suck on. The horses are wearing leather strip "fly nets" which moved as the animals walked, thus "shooing" away horseflies.

Seen here in 1903 is the Heller & Staats Grocery, 919 South Fifth Avenue. The concept of self-service was nonexistent in those days. Everything from cookies to kerosene was weighed out per order. Hitching posts were located in front of every business and most homes.

This 1906 view looks north on Fifth Avenue from the North Western railroad tracks. Note the streetcar tracks and the new electric streetlights hanging overhead.

It was possible for average working families to become homeowners in Maywood. This postcard, mailed in 1910, shows 134 and 136 South Sixth Avenue. Both homes, built in the 1870s, are still standing.

Delivery was the rule, not the exception, in the early 20th century. Many Maywood youths drove wagons for various markets. Here Bernard Mueller delivers groceries for Shuette & Sons, Fifteenth Avenue and St. Charles Road, in 1907. Mueller lived at 1010 South Fifth Avenue.

Humphrey and Katherine Millet are seated in the first gas buggy in Maywood, 1902. If the Millets were out on the dusty roads instead of posing for a picture in their yard, 802 North Third Avenue, they would be wearing long "dusters," goggles, and gloves. Mrs. Millet would wear a heavy protective veil.

All of the 225 new homes built in the village in 1904 were equipped with electricity and indoor plumbing. Maywood was becoming recognized for its strong housing stock.

The Chicago, Aurora & Elgin, an electric railway line, served Maywood from 1902 until 1957. Many families settled in south Maywood because of this swift, affordable means of transportation. Electric power was obtained from a third rail instead of overhead wires, as with the streetcars. Highly dangerous to trespassers, the third rail was not laid through crossings, so the lights blinked on and off with annoying frequency. This is the Fifth Avenue stop at Wilcox Avenue, c. 1904.

Until the 1900s, photography was reserved for professionals. The cumbersome equipment was difficult to use. Few could afford a fully equipped darkroom or the necessary chemicals. But with a Brownie box camera, "snapshots" like this one of cousins at a picnic were easy to shoot, revealing families' casual, lighter moments.

The Butz Sisters Millinery Shop, 18 South Nineteenth Avenue, was a thriving business establishment. These Butz creations show how large and profusely decorated women's hats were in 1910.

Much of Maywood's social life was free, centering around church events or public patriotic holidays. This 1915 photo shows the annual May Day Frolic held behind the library, in front of the lagoon.

By 1908 Bell Telephone insisted its operators use the query "Number please?" Though Bell regulations strictly forbade "monitoring" calls, eavesdropping was a constant temptation in the days before automatic dialing.

This photo shows the kick-off parade for the annual American Can Company employees' picnic, heading eastbound on St. Charles Road. After the games and food there was a fireworks display in Maywood Park to which the entire village was invited.

Seen here in 1910 are Herman Hoffie, a broker, and his wife Helena, standing in front of their home, 408 North Eighth Avenue, with their children, Irene and Walter. In the era before radio, television, and air-conditioning, people spent a lot of time on their wide front porches and knew their neighbors well. The porch is now enclosed.

Kodak ads promised, "You press the button—We do the rest." Until then the word "snapshot" was strictly a hunting term for a quick shot without careful aim. In August 1914, just as World War I was breaking out in Europe, the Davis sisters posed in their backyard, 608 North Fifth Avenue.

After the Benson family home was destroyed by fire in 1913, the entire neighborhood mobilized and rebuilt their house on the 1000 block of North Fourth Avenue.

The close proximity to so many open fields, the deep woods, and the Des Plaines River, provided the children of Maywood with a feeling of closeness to nature in the early 20th century.

The Maywood Speedway was an auto racetrack that ran between First and Ninth Avenues, south of Roosevelt Road. This 1915 photo shows an auto driven by Barney Oldfield (1878–1946), the "Speed King of the World." Oldfield broke records as the first man to drive a car at a speed of a mile a minute.

The autos usually began in staggered intervals with two or three cars starting at the same time, racing against the clock. The open countryside of south Maywood was a popular location in which to enjoy automobile races in the 1910s.

This 1912 photo shows Plummer's Garage, the northeast corner of First Avenue and Lake Street. Maywood's blacksmiths, harness shops, and livery stables were rapidly being replaced by garages and filling stations. Note the Lake Street streetcar tracks on the brick pavement.

Probably no other auto had more impact on the daily lives of average people than did the Model T Ford. This sturdy, reliable, affordable 1914 model cost $290. From 1908 to 1927 Henry Ford insisted you could have any color "Tin Lizzie" you wanted, as long as it was black.

47

The Great Migration, one of the largest population shifts the nation ever experienced, was a mass movement of African Americans from the rural South to the industrial North, starting during World War I.

The severe labor shortage caused by the draft and the tapering off of immigration during World War I led to the recruitment of women and African-American workers by the American Can Company.

The troops were still highly segregated during World War I. These recruits wait at Fifth Avenue and St. Charles Road for their train to basic training. Despite the "Jim Crow" atmosphere, African-American soldiers earned an impressive number of awards for combat bravery defeating the German troops.

These Red Cross workers, most of them wives or mothers of men "over there," are riding in a patriotic parade down Fifth Avenue in 1918. Their auto has just passed Maywood Hall at Fifth Avenue and St. Charles Road. Note the mortar and pestle hanging in front of the pharmacy.

Despite a national epidemic of "Spanish Influenza," there were lots more glorious parades when the troops came marching home at the end of World War I.

The 1920s began with a roar when a tornado struck at 12 noon on Palm Sunday, March 28, 1920, wreaking havoc and killing 11 people. Seen here is the Butz Sisters Millinery Shop, 18 South Nineteenth Avenue. After their store was destroyed, the sisters reopened at 512 Lake Street.

Three

SUBURBIA

During the 1920s, the nation's economy was booming. Hundreds of bungalows and scores of apartment buildings were constructed in Maywood. The village doubled its population during the decade, reaching nearly 26,000 by 1930. The business district was thriving and expanding. There were three movie theaters on Fifth Avenue. Miller Meadow at First Avenue and Roosevelt Road became a landing strip called Checkerboard Field.

The 1930s brought "hard times," the worst in American history. Maywood State Bank was one of thousands that failed, taking depositors' life savings with it. The Great Depression hit Maywood hard. Yet many villagers found work in federal projects, like the W.P.A. and the C.C.C.

During World War II, almost every Maywood family had someone in uniform. There were bond drives, rationing, patriotic parades, and a massive draft. The 1942 Bataan Death March in the Philippines, in which many Maywood troops perished, remains one of the most infamous episodes of the Second World War.

This promotional logo was widely featured in the Maywood press and real estate literature of the early 1920s

Maywood enjoyed a thriving business district during the 1920s. This postcard view looks north on Fifth Avenue from Main Street.

At American Can, African Americans and whites worked together, receiving equal pay for comparable jobs. But despite the economic prosperity of the 1920s, a pattern of residential segregation persisted within Maywood.

Airmail service was first inaugurated and operated by the Post Office Department in the early 1920s from a landing strip called Checkerboard Field, First Avenue and Roosevelt Road. Here is one of the early airmail planes being loaded for take-off. The pilot had to straddle sacks of mail as he flew the machine.

By the time these 1920s "flappers" posed for a picture at Maywood Airfield, where Loyola Medical Center is now located, airmail was no longer just a novelty but was becoming a reliable means of postal delivery.

Bungalows, often criticized for their lack of uniqueness, provided solid, affordable housing for many new Maywood families. These frame bungalows were priced in the $2,000 range in 1924.

Bungalows provided homeowners with the latest conveniences. This red brick home, 1444 South Fifteenth Avenue, had a sun parlor, an enclosed back porch, a breakfast room, a sleeping porch, a laundry chute, and a built-in ironing board in the kitchen.

Established in 1919 for the care of World War I veterans, Edward Hines, Jr. Memorial Hospital was erected at Fifth Avenue and Roosevelt Road on the 320-acre site of the bankrupt Maywood Speedway. The Maywood Airfield is visible in the background.

The extraordinary shape of Hines Hospital's four-story main building was dictated by the dimensions of the auto racetrack grandstand that provided its foundation. This postcard, mailed in 1921, says, "Dear Papa: So far, so good. Doctors optimistic. Fish for dinner tonight. Haven't gotten any mail yet. Tell Stella to write. Your son, Herbert."

This postcard view of the 100 block of South Fifth Avenue, c. 1925, shows the library and Village Hall on the right.

The imposing new façade of the Maywood State Bank at Fifth Avenue and Lake Street is seen in 1924. After standing vacant for decades, the building reopened in 1996 as the Maywood Fine Arts Association, a non-profit organization that provides arts training for low tuition.

These teenagers have paused for a picture at the Proviso Junior-Senior Promenade or "prom" in 1924. Such popular social events during the Jazz Age were routinely held in the gymnasium with a live orchestra. The Charleston, a vigorous, knock-kneed dance step, was highly popular at the time.

Don't touch that dial! During the 1920s, the radio became the most important piece of furniture in many Maywood living rooms. Lots of people reported staying up "half the night" listening to the new medium.

Buy Your Victrola at Home

OUR PRICES AND TERMS AS LOW AS ANYWHERE. OUR STOCK IS ALL NEW STOCK AND OUR SERVCE CAN NOT BE EQUALED

J. J. Willis & Son

118 SOUTH FIFTH AVE.
MAYWOOD

Model XI, $150.00

While every family in 1900 wanted a piano in their parlor, by 1920 people fell in love with the Victrola, an upright, hand-cranked phonograph that could be easily purchased "on time." Buying on credit became a standard practice in the stores along Fifth Avenue. Shop owners encouraged customers to put a small amount down, and then pay off the balance in monthly installments.

This 1929 aerial view looks north toward Proviso Township High School, just west of the Des Plaines River. Several years later, during the Great Depression, there was a hobo shantytown or "Hooverville" along the riverbank.

During the 1920s, many brick apartment houses were built within walking distance from the trains and streetcar lines. This 1925 postcard shows Maywood's first "courtyard building," constructed at North Third Avenue and Main Street.

The two women in the middle are the Butz sisters, Clara and Mary, in their successful hat shop, 512 Lake Street, c. 1925. The unidentified clerks on either side are "milliners' assistants." Note the stamped tin ceiling and the many hand-made cloche hats on display.

Not a creature was stirring on Fifth Avenue, looking south from Lake Street, when this photo was taken on Christmas Eve, 1923.

For decades people came to Maywood to purchase their new automobiles. There was an average of eight different auto dealers, including many makes of cars that no longer exist, such as the Auburn, DeSoto, Hudson, Kaiser, Hupmobile (seen here in 1923), Maxwell, Packard, and Reo.

60

In 1928, a branch library opened at 1213 South Seventeenth Avenue in a former real estate office. The structure is no longer standing.

The Maywood Police Department purchased two new "cop cars" in 1929. Officers Ed Feldman, 619 South Fourth Avenue, and John Peterson, 906 South Ninth Avenue, stand proudly by the new vehicles.

Chain stores increased in popularity during the 1920s. The Atlantic & Pacific Tea Company (right), popularly known as the "A & P", seen here in 1928, was a grocery that carried brand names people knew from radio commercials, like Campbell's soup, Nabisco cookies, Ivory Soap, and Kellogg's cereal. These buildings are all still standing.

In 1929, when the Maywood Fire Department purchased a pricey new hook-and-ladder truck for $11,000 the firemen lovingly dubbed it "The Red Monster." The 1904 firehouse still stands on St. Charles Road, just west of Fifth Avenue. The building was renovated as a private residence in 2004.

With the arrival of summer, these boys found the lagoon south of the railroad tracks in Maywood Park a pleasant spot to keep cool in 1929. During the next decade the pond was drained and filled in as part of a federal mosquito abatement project.

Sego's Barbershop, 108 South Fifth Avenue, provided a popular forum for socializing and exchanging information in the late 1920s. Owner Harry Sego is on the right.

Oscar and Linnea Sanders, a Swedish immigrant couple, lived above their shoe store at 511 Lake Street when this photo was taken in 1925. The building is now the home of the Abundant Life Church.

The Young People's Club of St. Eulalia's Parish posed with Father William F. Owens (right) in 1927. Many of the girls are wearing typical 1920s cloche hats pulled down like helmets to their eyebrows.

Seen here is General Motors' 1929 "Frigidaire," for sale at Ben Silverman's Hardware, 718 South Fifth Avenue. The appliance became so popular that people often erroneously used the trade name as a generic term, calling any electric refrigerator a "frigidaire."

Don Antonio's Pharamacy, 501 Madison Street at Fifth Avenue, offered free delivery service and a soda fountain where teens met after school. Though the building now has a different "face," the structure survives as a currency exchange.

The 1926 Proviso State Bank, 409-411 Madison Street, cost $60,000 to construct. It was praised for its Doric columns and classical symmetry. Bank architecture had to symbolize strength and security.

This November 1937 photo looks east on Madison Street from Fifth Avenue. Note the "lunch counters" and small shops (left) adjacent to the Proviso State Bank. This intersection was where streetcar commuters transferred from the Fifth Avenue car to the Madison line.

The Odd Fellow's Building, a 1920s lodge hall, had an auto dealer's showroom on the first floor. The structure survives on the northwest corner of Washington Boulevard and Fifth Avenue. Lyceum Hall upstairs could be rented for social affairs. Note the raised storm drains in the street.

This "fall formal" in October 1939 was hosted by the Canaan African Methodist Episcopal Church at Lyceum Hall (above). Wrist corsages were "the latest thing."

Though the gambrel roof reminded many people of barns, the Dutch Colonial style was a very popular home during the building boom of the 1920s. There were 30 different kinds of flowers in the yard of this home at 1603 South Fifteenth Avenue in 1924.

The Baptist Old People's Home (later renamed the Baptist Retirement Home) at Fourth Avenue and Randolph Street was said to offer "a little bit of sunshine in every room." In 1938, when this postcard was sent, 125 persons over age 70 resided here. An on-site hospital with a staff of eight nurses cared for the sick and infirm. The structure is still standing.

Maywood was widely recognized for its strong housing stock. Seen here in 1926, this California Bungalow was set far back from the street at 1107 South Sixth Avenue. There was a rustic style natural rock chimney and a goldfish pond.

The Children's Receiving Home on the northeast corner of Madison Street and Ninth Avenue was a Lutheran shelter for 60 children. The three-story red brick building cost $100,000 to construct in 1926. The building is now owned by the Maywood Park District.

There were three movie theaters on Fifth Avenue in the 1920s. This postcard, mailed in 1926, shows the Lido Theater, 620 South Fifth Avenue. According to the marquee, the feature that week was For Heaven's Sake, a fast-paced silent comedy starring Harold Lloyd. There's a strip mall on this site today.

The 1,800-seat Lido Theater was open from 1925 until 1976. In the early years, live vaudeville acts performed between the feature films. The Lido converted to "talkies" in 1929.

When the Phoenix Hospital (page 96) was razed, it was replaced with the Maywood Theater, 115 South Fifth Avenue. Oliver W. Haines, a Maywood piano tuner who lived at 913 North Ninth Avenue, launched a new career playing the $9,000 organ during the silent movies. After the theater was torn down it was replaced with a supermarket, which was also subsequently razed in the 1970s. The lot is now empty.

CHARLIE CHAPLIN in "THE GOLD RUSH"

This 1925 lobby card for Charlie Chaplin's comedy The Gold Rush is from the Yale Theater, 1008 South Fifth Avenue. The Yale, a small 500-seat movie house, was open from 1916 to 1952. The yellow brick building with terra cotta urns on the top survives as a restaurant.

The Lido Theater offered live vaudeville acts as well as movies. This promotional flyer shows one of the headlining acts of 1932, The Hoosier Sod Busters. The performer in the middle, known as "Spareribs," was a white singer/comedian who performed in blackface, a racist showbiz tradition from minstrel show days.

In 1932, a decade before World War II shortages motivated villagers to raise their own crops in Victory Gardens, the Maywood Community Garden became a Great Depression model throughout the region. Seen here are the civic-minded businessmen who conceived the project, which utilized several vacant prairies where the Eisenhower Expressway now bisects Maywood. Nearly 200 unemployed people tilled the ground that produced a large crop of foodstuffs for the needy.

Despite the Great Depression, American Can's payroll numbered over 2,500 employees in 1938.

Fruit and vegetable salesmen made the rounds of Maywood neighborhoods. Note the brick streets at Sixth Avenue and Huron Street in 1937.

Printed Chiffon Frocks....

Hemlines dropped when "hard times" hit. These summer floral print frocks were on sale at the Lido Fashion Shop (adjoining the Lido Theater), 612 South Fifth Avenue, in 1931.

The new Maywood Post Office, 415 South Fifth Avenue, featured eight Ionic columns and classical symmetry. Until then, the post office was located on the first floor of the Masonic Temple (page 106).

During the 1930s, the W.P.A., or Works Progress Administration, constructed a new storm sewer system with 480 manholes. Its installation provided steady employment for hundreds of out-of-work Maywood men during the depths of the Depression. They also repaired and repaved many sections of the brick streets, as seen here on North Sixth Avenue in 1936.

Mike's Suburban Collision Shop, an auto body service, opened at 512 Madison Street at Sixth Avenue in the early 1930s. Mike Yaccino Sr., the founder, is seen at the left, c. 1936. The shop, now located across the street, 511 Madison Street, is operated by the third generation of the Yaccino family. The Standard Oil filling station survives as a carwash.

75

This view looks north on Fifth Avenue at Main Street in 1937. Despite the Depression, there were numerous businesses thriving on that block, such as the Grupe & Turk Pharmacy (left) with its soda fountain and lunch counter, a Western Union office, a meat market, and a "dime store."

The two-story brick Village Hall was completed in 1897. There was a one-cell jail and a gun practice range located in the basement. This 1938 photo shows three new Maywood "police sedans."

The Maywood Home for Soldier's Widows, 224 North First Avenue, opened in 1924. Today the structure is unused and boarded up.

The aviator on the left is Albert Stump, who lived at 610 South Thirteenth Avenue. Stump was one of 673 single-engine Tuskegee Army Air Field pilot graduates who formed the four squadrons of the 332nd Fighter Group during World War II. The "Tuskegee Experiment" proved that African-American men could fly state-of-the-art aircraft and could conduct highly successful combat operations.

77

Maywood was home to the 33rd Tank Company, Illinois Nation Guard (Company B). The Armory, 50 Madison Street, two blocks east of First Avenue, survives as Saltzman Printers, Inc. One hundred and twenty-two men of Company B were inducted into active service to become part of the famous 192nd Tank Battalion which fought on the Philippine Islands. They were destined to become victims of the Bataan Death March in April 1942.

The Bataan Death March was an infamous episode of World War II. Seven to 10,000 weakened prisoners of war died of starvation, exhaustion, and merciless beating along the enforced march by their Japanese captors. Only 41 men of the original 122-man Company B returned to Maywood alive after the war.

Bond drives raised revenue to help finance the war. These Proviso High students are selling defense stamps in the cafeteria in 1943. Campaigns to collect rubber and scrap metals also added to the public's sense of participation in the war effort.

The scarcity of materials, such as petroleum, rubber, coffee, sugar, nylon, and even meat, made rationing a way of life during World War II. This gas ration stamp book was issued by the Office of Price Admission.

Chain stores were prevalent on Fifth Avenue by 1942. Note the "service star flag" in the second floor apartment window above the F.W. Woolworth dime store, 20 North Fifth Avenue, which indicated the residents had a son serving overseas.

Women played a key role in manufacturing during the manpower shortages caused by World War II. The American Can Company did defense work on a seven-day, round-the-clock schedule. These women are making ammunition canisters.

Four

CHURCH BELLS AND SCHOOL BELLS

Churches were the first public buildings to be constructed in early Maywood. Not only did these places of worship serve the spiritual needs of the community, they also provided a key setting for socializing. Before long, the rapidly growing population of Maywood became so diverse that a variety of churches were required. Much of Maywood's strength and endurance can be attributed to its extensive spiritual community. In 2004, there were over 30 places of worship in the village. It is impossible to include them all within this volume.

The earliest Maywood public school, seen pictured below, also functioned as a house of worship and a meeting hall. Miss Clara Steele, the first elementary teacher, was hired at the rate of $25 per month. Maywood was known for its fine, up-to-date schools with progressive curriculums. There were two schools in the first decades, the North Side School (later named Lincoln School) and the South Side School (Emerson School). High school classes were held upstairs in the building below for many years.

The earliest school in Maywood, 311 Washington Boulevard, was erected in 1859 to serve as a combination meeting hall, church, and classroom building. The structure was used until 1930 when it was razed on the day this photo was taken.

This is the Episcopal Church of the Holy Communion on the southeast corner of Fifth Avenue and Oak Street, c. 1912. The earliest services of this congregation were held in the railroad station in 1871. Many prominent Maywood families, including founder Colonel Nichols', attended services here.

First Baptist Church of Maywood, on the southeast corner of Fifth Avenue and Randolph Street, was erected in 1912. The charter of the congregation's first house of worship was secured in 1875. By the time this postcard was mailed in 1913, there were 515 active members.

St. John's English Evangelical Lutheran Church, 1208 South Fifth Avenue, is seen in a 1910 postcard view. In its early years, the church was closely associated with the Lutheran seminary (below).

This postcard shows Chicago Lutheran Theological Seminary, which occupied 15 acres of land—six city blocks—bounded by Van Buren Street, Tenth Avenue, Harrison Street, and Thirteenth Avenue. The school was first founded in 1891 where Wrigley Field is now located on Addison Street in Chicago. The seminary, which offered a degree of Bachelor of Divinity, moved to Maywood in 1910. By 1930 there were 11 buildings on campus. P.A.E.C. or Proviso Area for Exceptional Children, a special education facility, now sits on these grounds.

83

The Neighborhood Methodist Episcopal Church, 1817 Washington Boulevard, was dedicated in 1902. For five years before that, members held services in private homes and public halls. The streetcar ran down the middle of Nineteenth Avenue.

The First Congregational Church was organized in 1871. For 50 years it occupied a frame structure on the northwest corner of Lake Street and Sixth Avenue that was razed in the 1920s. The church then moved to its current location, 400 North Fifth Avenue. These First Congregational Church members are visiting after services, June 12, 1910.

Because of the restrictive residential covenants in most suburbs, few Jews lived outside Chicago before 1950 except in Maywood. The B'nai Israel congregation, located at 433 South Thirteenth Avenue, built their synagogue in the early 1900s. The iron fence which surrounded the temple was taken down and donated to the scrap metal drive during World War II. The structure survives as a branch of the Second Baptist Church.

Canaan African Methodist Episcopal Church was located at 621 South Thirteenth Avenue when this photo of the choir was taken in 1953. The church, organized in the early 1900s, is now located at 801 South Fourteenth Avenue.

The First Methodist Church (1912) at 502 South Sixth Avenue was designed by noted Prairie School architect William Drummond, one of Frank Lloyd Wright's studio draftsmen. Following an octagonal plan, the building replaced an early wooden structure that was hit by lightning and burned to the ground. Known as "The Friendly Church," its motto was "Only Once A Stranger." The building is now home of Christ Temple Church of the Apostolic Faith.

During the period of racial unrest and protest in the 1960s, young people often met at Rock of Ages Baptist Church, 1309 Madison Street, to plan their strategy. This overflow crowd just participated in a 1967 demonstration against the lack of recreation facilities in Maywood. Rock of Ages, considerably expanded, was rebuilt on the same site in the 1990s.

Rev. Wallace Sykes of Second Baptist, the first African-American church in Maywood, moved to the village in the 1940s as a teenager. He became pastor in 1961 and continues to serve in that capacity. Reverend Sykes is seen here in 2001 at a celebration of his 40 years with the Second Baptist Church.

There were so few homes south of Washington Boulevard in 1884, when this photo was taken, that the school eventually named Emerson, 111 Washington Boulevard, was known for years simply as "the South Side School." For many families, the annual class photograph was often their only visual record of their children growing up.

In 1900, these seventh graders posed in front of patriotic stars and stripes bunting at the "South Side School." Thinking was discouraged in favor of memorizing facts and noble thoughts. "Practical Penmanship" rigorously followed the Palmer Method.

Father James O'Shea, the first pastor of St. James Parish, is seen in the top row, center, in this photo of the school's First Communion class in 1917.

St. James Roman Catholic Church, 307 South Seventh Avenue, was less than a year old when this postcard was mailed in 1909.

This production of Ali Baba and the Forty Thieves was the eighth grade class play presented at Washington School in 1932. The student body was a mix of Jewish and African-American children. Abraham Weinberg played Ali Baba and Stewart Pearce was his son.

This first brick version of Lincoln School, Chicago Avenue at Eighth Avenue, was erected in 1908. It replaced a frame schoolhouse.

School desks were nailed to the floor and each one held an inkwell in 1915. This is the sixth grade at Lincoln School. Education consisted of copying, memorization, and recitation. Good spelling and graceful penmanship were primary goals.

These second graders are showing their school spirit during a pep rally at St. James Catholic School in 1990. Strong parochial and private schools provided a viable option for Maywood families from the early days of the community.

There was no separate high school building for Maywood teens in 1893. These students attended classes upstairs in the old brick "meeting house school" (page 81). Most young people joined the work force right after eighth grade. A high school diploma was not only a badge of academic achievement, like a college degree is today, but was also a luxury most families could not afford.

By 1911, when the first Proviso Township High School was constructed at First Avenue and Madison Street, courses in history, the sciences, and the "manual arts" had been added to the basic high school curriculum of reading, writing, and arithmetic. This structure survives as the southwest corner of Proviso East High School.

The increasing high school enrollment reflected the growth of the middle class in Maywood. Holding their diplomas in their laps are the eight members of the first graduating class at Proviso Township High School, seated with the faculty and Board of Education in 1911.

In 1930–1931, there was massive construction and expansion at Proviso Township High School. This large addition would become the trademark clock tower entrance, 807 South First Avenue (*below*).

Enrollment at Proviso Township High School had grown from 241 in 1911 to nearly 4,050 when this postcard was mailed in 1938. Not only had Maywood increased in size, but there were fewer jobs to lure young people into leaving school early during the Great Depression.

93

The huge Proviso High School Fieldhouse was completed with funding and manpower from the federal W.P.A. program. This is the cover of the official dedication program for the new facility in 1938.

Maywood's long been known for its enthusiastic support of local sports teams. These boys from Washington School won the grade school basketball tournament by beating the Lincoln School team in 1932. Miss Jean Currie (left) was their coach.

Five

"Wish You Were Here"

Today we think of writing postcards as strictly a vacation ritual. We jot a few lines on the backs of scenic views to brag about our trip while we show friends and family they're not forgotten. Picture postcards were used quite differently in the early 20th century, however. Cheap and relatively speedy, they were the e-mail of their day.

A penny postcard cost only another cent to mail. Many households still did not possess a telephone or they shared a party line. Since mail was sorted at all times and there were several deliveries per day, a postcard might arrive within a couple of hours after it was sent. So "dropping a line" via picture postcard became a perfect way to communicate—while also passing along a favorite village view.

Postcards were widely used for holiday greetings in the early 20th century. Postmarked December 24, 1910, this card provided eight Maywood views for the price of one.

This 1906 postcard photo was taken while the Maywood Public Library (right) was still under construction. The 1870 Maywood Hotel was now the Phoenix Hospital, Fifth Avenue and St. Charles Road. Martha Luerhrs writes to her friend Lizzie: "I don't think I can come to your skating party. I have ironing to do Wednesday. I cannot skate anyway. I haven't had my skates on all this year. It don't make no fun for me if I cannot skate. I didn't have time to learn."

The Hotel Edward, 410 St. Charles Road, faced the railroad tracks (above, left of hospital). George Z., who wrote this postcard in 1914, raved about the "tasty goulash" he'd just enjoyed in the hotel dining room.

This postcard, showing Sixth Avenue just south of Madison Street, was mailed to Uncle Leo in Chicago in 1912. "We adore Maywood," reads the message. "Nearly all streets look like this one. Lots of fresh air and it is so clean out here. Love, Harriet."

By the early 1900s, the south half of Maywood Hall at Fifth Avenue and St. Charles Road was being used as a bank; the north half nearest the tracks contained a cigar store and news agency. Note the "guard house" (right) facing the railroad tracks.

97

This 1914 view shows the Machine Shop of the American Can Company. The vast plant contained three different factories, a laboratory unit, a truck garage and several warehouses.

Mailed in 1911, this postcard shows the American Can Company. Reuben wrote these lines to Ida: "My dear, this is where I now work on the top floor. Just across the streetcar track in the middle of the block is where I room."

This view, mailed in 1925, shows the Hancock Block, a new retail and apartment complex on the northwest corner of Sixth Avenue and Lake Street. The tan brick structure was built after the First Congregational Church was razed and then rebuilt at 400 North Fifth Avenue.

By the second decade of the 20th century, the horse had been largely replaced on Maywood streets. This postcard view of the 1400 block of South Fifth Avenue shows the popularity of the automobile by 1914.

This view, postmarked 1910, looking north on Fifth Avenue, shows the "guard house" (left) from where a watchman would raise and lower the safety gate whenever a train approached. "The trains made Maywood," old-timers used to say. All streets numbered north or south from the tracks. The village was serviced by both steam and electric railroad lines.

While views of local landmarks were widely sold, personalized photo postcards made in Maywood homes by itinerant photographers were also highly popular. This postcard was sent by Rose to Wendell in 1916.

Mrs. Maude Stump, 938 South Twelfth Avenue, sent this postcard to her mother in Nashville. It is postmarked December 25, 1907. "Dear Mama," the message begins. "Here's Baby Albert's photo for you. Am so very sad and lonesome tonight." (See Albert on pages 32 and 77.)

William and Julia Heideman, 417 North Third Avenue, had this postcard made of their family in 1916. Mr. Heideman was a teller in the Maywood State Bank.

101

This postcard of the lagoon in Maywood Park bears this 1909 message from Minnie to Howard: "My Darling, I got here safe but with an awful headache. Train an hour late. Papa still ailing but Maywood looks grand."

Fifth Avenue just south of the North Western railroad tracks is seen in this 1911 view. Note that Maywood traffic was now a mixture of horse-drawn vehicles, streetcars, and autos. The aging Maywood Hall (right) would stand for another two decades, then would be replaced by a Pure Oil gas station.

Andrew Carnegie (1835-1919) was a steel baron who late in life dedicated himself to philanthropy on a grand scale. At the turn of the 20th century he funded over 2,500 libraries. This 1908 postcard shows the two-year-old Maywood Library, 121 South Fifth Avenue, with its standardized "Carnegie Design." One entered through a ceremonial portico of Grecian pillars.

Note the ice wagon heading down Sixth Avenue from St. Charles Road, c. 1910. Maywood Hall is on the right. The fire department and water works buildings in the center of the photo are still standing.

103

The classical Masonic Temple, c. 1917, at 200 South Fifth Avenue, housed the Maywood Post Office on the first floor until 1932. Today this imposing structure is headquarters of the Parks and Recreation Department.

The American Can Company continued to expand during the early decades of the 20th century. This 1911 postcard, showing the streetcar tracks turning off Fifth Avenue onto St. Charles Road, shows the factory buildings and water tower on the right. On the back of this view, Clarence wrote to Ada: "This wonderful little burg is only an hour from Chicago—just a dime fare via the streetcar line."

This view of the intersection of Lake Street looking east at Fifth Avenue was mailed in 1909. Olga wrote to Gladys: "Rode 46 miles today in an automobile. Never again!"

"Hazel and I are enjoying a pleasant sojourn in the wilds of Maywood," is the short message on the back of this postcard, mailed in 1916.

The Bennett Apartments, Oak Street and Fourth Avenue, still standing, face Maywood Park. Viola wrote to Fred in 1911: "Dear Brother: Ma says she's arriving Wednesday morning on the 7:45. Where will I put her?"

Mailed in 1908, this view shows the tranquil Des Plaines River with the Lake Street Bridge in the distance. The old arched bridge was replaced several years later.

Heavily used Maywood Park was celebrated with many postcard views. Founder Colonel Nichols' farsighted plan to set aside a large tract as the "Village Green" provided Maywood residents with shade and respite from the bustle of Fifth Avenue.

Automobiles made people increasingly mobile. This view shows Fifth Avenue, looking south from the railroad tracks, in 1923. The buildings in the foreground on both sides of the street are long gone. The West Town Museum of Cultural History is now located on the right.

This 1912 postcard shows the Aurora, Elgin & Chicago line before the name was changed (1924) to the Chicago, Aurora & Elgin. Since the electric railroad ran 24 hours a day, it was a great convenience for night workers and those attending theater or other entertainment in the Loop. Much of the roadbed was built upon once the tracks were dismantled in the 1960s.

This view shows the busy corner of Fifth Avenue and Lake Street in 1928. The tall classical columns on the façade of the Maywood State Bank gave the building a staunch, formidable look. There the upper floors contained medical offices.

Six

Maywood's Hall of Fame

Maywood has produced an impressive number of gifted native sons and daughters, as well as scores of other significant folks who for a time were simply just "passing through."

Proviso East High School has been the home of many well-known over-achievers, such as Mayor Ralph Conner, who graduated in the Class of '66 with political activist and martyred Black Panther Fred Hampton. The list of Maywood sports heroes, including Jim Brewer ('69), Joe Ponsetto ('74), Glenn "Doc" Rivers ('80), and Michael Finley ('91), is especially awesome. From the surviving Bataan heroes of World War II to the late Jacqueline B. Vaughan, president of the Chicago Teachers Union, from playwright Tom Sharkey to jazz critic Mark Ruffin, Maywood has been the home of a vast number of special individuals who made their mark. Glenda Hardman Gwynn, who grew up in Maywood and graduated from both Washington School and Proviso, became the first African American principal of Proviso East High School. This brief chapter provides only a sampling of Maywood success stories.

Mayor Joe Freelon and his wife Gladys celebrate his victory in the 1982 election. Freelon was Maywood's first African-American mayor. Under his leadership the long-vacant American Can plant was finally demolished after several decades as the village eyesore.

109

Carl Sandburg (1878–1967) was working as a reporter for the Chicago Daily News in 1914 when he submitted a number of poems to Harriet Monroe's two-year-old Poetry magazine. His lead poem, called "Chicago," began: "Hog Butcher for the World, Tool Maker, Stacker of Wheat." Sandburg was 38 in 1916 when this photo was taken in Maywood.

This 1970s view shows Sandburg's home, 616 South Eighth Avenue. His great early works were published while he lived here from 1914 to 1919. Sandburg received three Pulitzer prizes: one for his multi-volume biography of Abraham Lincoln and two for his poetry.

Dennis Franz Schlacta (1944–), 1518 St. Charles Road, played a crook named "Poison Eddie" (in checked suit) in a 1962 Proviso East High student production. After graduating from Southern Illinois University and serving in Viet Nam in a reconnaissance unit, Dennis Franz dropped his last name and went into acting full time.

Dennis Franz, shown here in 1983 playing a baseball coach on "Bay City Blues," also appeared in the hit TV series "Hill Street Blues." In the 1990s, Franz played Detective Andy Sipowicz on the ABC police procedural series "NYPD Blue."

111

Fred Hampton (1948–1969) 804 South Seventeenth Avenue spoke out strongly against police brutality. While still in his teens, as youth chairman of the N.A.A.C.P., he became a well-known political activist. He led 300 citizens in a march on the Maywood Village Hall in 1967, protesting the absence of a municipal swimming pool in the community.

Though only in his early 20s, Fred Hampton was a nationally known Black Panther when he was killed during a Chicago police raid on his West Side apartment on December 4, 1969. Today the Fred Hampton Pool, seen here in 1973, is a tribute to both the man and his struggle for better recreational facilities in Maywood.

John Prine (1946–), 1964 graduate and former Maywood mail carrier, has been a popular folk singer and songwriter for nearly four decades. Both his parents were originally from Appalachia. The Prine family lived at 1110 South First Avenue.

Bessie Coleman (1893–1926) was both the world's first African-American female pilot as well as the first woman to receive an international pilot's license. The daring aviatrix gave flying demonstrations and often entertained the excited crowds at Maywood's Checkerboard Field just south of Roosevelt Road and east of First Avenue in the early 1920s.

Walter Burley Griffin (1876–1937) was one of America's greatest architects. Born in Maywood during the early days of the community, by the 1900s Griffin was employed by Frank Lloyd Wright at his Oak Park studio. In 1912, he won a competition to design the new capital city of Canberra, Australia.

Mary A. Mitchell, a current resident of Maywood, is an award-winning *Chicago Sun-Times* journalist. She's a frequent guest on WTTW-Channel 11 and often appears on "Fox News in the Morning." Mitchell is a recipient of many journalism awards, including the Studs Terkel Award from the Chicago Media Workshop, and the Award of Excellence from the National Association of Black Journalists.

Charles A. Lindbergh (1902–1974) was a young airmail pilot who rented a room at 1700 South Third Avenue in the mid 1920s while he was flying in and out of the Maywood Airfield. He's seen here after his solo, non-stop flight across the Atlantic Ocean in 1927. Lindbergh went from being a national superhero to being branded as a traitor during World War II when the antiwar activist was heavily criticized for his pacifism.

Dr. Percy Lavon Julian (1899–1975) a world-renowned humanitarian and scientist, was a pioneer in the chemical synthesis of cortisone and hormones made from soybeans. Julian, who lived in a brick bungalow at 152 South Fourteenth Avenue, was active in the Maywood Branch of the N.A.A.C.P. and served as President of the Washington School P.T.A.

Astronaut Eugene Cernan (1934–), who lived at 2018 South Eighteenth Avenue as a child, eventually left footprints on the moon. The Class of '52 graduate from Proviso High piloted the Gemini 7 mission in 1966, Apollo 10's trip around the moon in 1969, and the final Apollo missions in 1972.

Lifelong Maywood resident, still actively involved in his community, Hugh A. Muir (1909–) is seen celebrating his 95th birthday on March 15, 2004. He is a founding member of the Maywood Chamber of Commerce from the 1930s and had been a village trustee for many years. Muir and his brother Henry ran Muir Bros. Meat Market, 18 North Fifth Avenue.

Seven

CHANGE AND CHALLENGE

The post-World War II period was a time of accelerating change for Maywood. Race relations became an increasingly pressing matter by the 1960s. Due to "panic peddling" and unethical real estate practices, the village experienced rapid rates of "white flight." After the American Can Company closed in 1972, the impact on the community was devastating. A large portion of Maywood's population found themselves unemployed. The once thriving business district quickly deteriorated. Following increasing reports of criminal activity, Maywood went into a slump.

Yet despite the physical decay and economic decline which often characterized the village in the late 20th century, there remained a resilience and a commitment to community uplift among a solid core of community boosters who never gave up on Maywood.

As the 135th anniversary of its founding is being commemorated, it's clear that this historic suburb is populated by an exciting mix of long-time residents and enthusiastic newcomers who join together in proud celebration of the rich heritage of Maywood, Illinois.

By 1996 when Lois and Ernest Baumann opened the Maywood Fine Arts organization in the abandoned Maywood State Bank, 25 North Fifth Avenue (page 56), the building had been boarded up for decades. The legendary Ms. Baumann (right) is seen on Fifth Avenue just south of Lake Street at the 2003 Maywood Fine Arts Walk.

Soldiers returning home to Maywood after World War II were eager to start families. These two little "baby boomers," Sharon (b. 1948) and Connie Pitt (b. 1946), are with their father, Hubert Pitt, in front of their home on South Seventh Avenue. Pitt was principal of Proviso East High School during the 1960s.

This snowy, early 1950s view shows the intersection of Fifth Avenue and Lake Street. The building on the corner, an Osk Kosh "work clothing" store, burned in 1953. Note the three-story Opera House (left). An F.W. Woolworth's "dime store" was located on the first floor.

To honor the memory of those Maywood men who perished in the Philippines in World War II, annual Bataan Day Parades were held every year, the second Sunday in September. In this mid-1950s photo, marchers are heading south down Fifth Avenue at Warren Street.

These children are enjoying their playhouse behind 1512 South Seventh Avenue. As various blocks began to "open up" to African Americans in the 1950s, whites living on adjacent streets often moved away. "White flight" was further exacerbated by scare tactics employed by ruthless realtors

119

During the 1950s and 1960s, no suburban community was complete without a full schedule of Little League Baseball. Social contact between blacks and whites in Maywood was often facilitated by such shared athletic and recreational activities.

These Proviso East students are dancing "The Twist" to juke box music in the high school's Social Room in 1962.

During the 1960s, the Civil Rights Movement initially brought black citizens and their white allies together to protest discrimination and unfair real estate practices. These demonstrators are picketing in front of the old Village Hall on Fifth Avenue.

Across Fifth Avenue from this 1960s demonstration can be seen Maypark Drugs, a small pharmacy attached to the Masonic Temple. This add-on structure was removed in the 1990s.

In the fall of 1967, Proviso East High erupted with what were initially dubbed in the press as "racial disturbances." Here helmeted sheriff's police line both sides of the First Avenue "tower entrance" while students show their ID cards to enter the building.

The whole world was watching! Since Proviso East was the first American high school to experience "race riots," the media coverage was relentless. Within weeks following the initial incident, two new industries dropped plans for relocating into Maywood. Several projected high-rise developments were cancelled. Other potential developers and investors pulled out, too, as racial conflict continued for several years.

Playmates Derrick Gardner and Andy Cooper are blowing bubbles in this 1973 photo. The Maywood bumper sticker, "Let's Make It Work," referred to a grass roots commitment to village diversity and economic growth.

With the formation in January 1974 of the Maywood Growth Corporation, the village and its residents committed themselves to a re-vitalization of business and shopping in the community. Note the Bataan Day banner in this photo, which looks north on Fifth Avenue from the Madison Street intersection.

This early 1970s group of Maywood adults and children boards buses in front of the soda fountain on the northwest corner of Fifth Avenue and Main Street as they head out on a fieldtrip together.

The "Cluever House," 601 North First Avenue, was listed on the National Registry of Historic Places in 1977, the first of many Maywood properties to be so recognized. Designed in 1913 by John S. Van Bergen, a Prairie School architect strongly influenced by Frank Lloyd Wright, this home appeared on the 1988 Maywood House Walk.

An overflow crowd waits patiently outside a historic Queen Anne-style home of the 1890s located on the northwest corner of Fourth Avenue and Maple Street on one of the Maywood House Walks in the late 1980s.

Located on a 73-acre campus at First Avenue and Roosevelt Road, Loyola University Hospital opened its doors on May 21, 1969, and continues to provide state-of-the-art medical care to Maywood and surrounding communities. Loyola was the site of the first heart-lung transplant in 1986. Here local children and young adults learn from each other during the Healthy Teen after-school program Loyola offered at Washington School in 2000.

For over three decades Lois and Ernest Baumann, seen here in 1995, taught thousands of Maywood children dance and gymnastics at their "Stairway of the Stars," located on the top floor of the 1890s Opera House, 22 North Fifth Avenue (page 20). The long-time Maywood residents' fourfold mission: to offer affordable lessons, to teach the love of dance, to provide a safe haven for local children, and to act as a springboard of opportunity.

The "Pink Ladies" are rehearsing scenes from the musical Grease at Maywood Fine Arts, 25 North Fifth Avenue, in 2003. Lois and Ernie Baumann work with 1,200 children a week in a variety of programs. In 2004, a popular offering of "Mr. Ernie's Flip, Flop, and Fly" program was a special tumbling class for Hispanic youths.

Beginning with the "Black Is Beautiful" movement in the late 1960s there was an exciting rebirth of pride in African-American culture. Here, in 1992, Danielle Hopkins, a pupil at St. Eulalia School, sings a gospel song during the second Black Heritage Expo.

Brenda Arredondo is reading with her younger brother Rafael in the large new Maywood Public Library in 2004. The Hispanic population has been the fastest growing segment of the village in the 21st century.

In 2001, the West Town Museum of Cultural History hosted the dedication of the Underground Railroad monument, seen here at the riverfront site of McDonald's, First Avenue and Lake Street. The original structure (page 10) was razed in 1927. Northica Stone, founder of the museum, located at 104 South Fifth Avenue, and curator Jeri Stenson, were pivotal in securing landmark status for the site.

Sheila Ferrari, children's librarian and lifelong Maywood resident, reads to young patrons at the expanded Maywood Public Library in March 2004. The building was dedicated 90 years to the exact hour of the dedication of the original 1906 library.